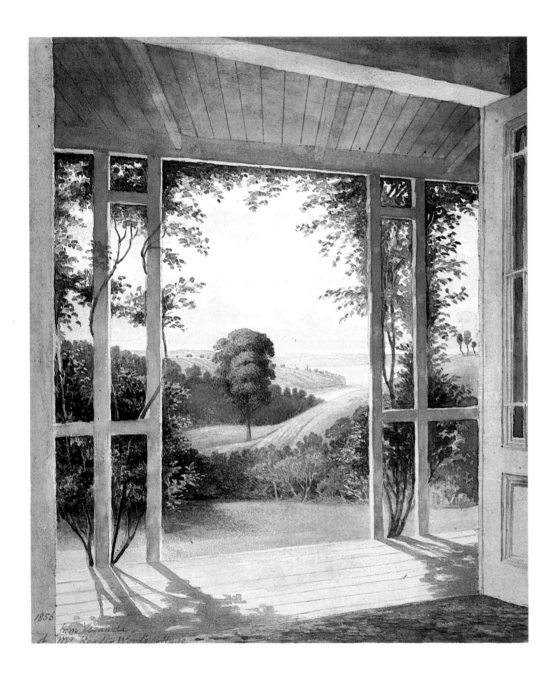

John KINDER   (1819-1903)
*Auckland, from veranda of Mr Reader Wood's cottage*
1856
pencil and watercolour, 290 x 248 mm
Auckland City Art Gallery,
presented by Harold A. Kinder, 1937

# TWO CENTURIES
of
# NEW ZEALAND
# LANDSCAPE ART

Roger Blackley

Auckland City Art Gallery

Published by
Auckland City Art Gallery
P.O. Box 5449
Auckland
New Zealand

Revised edition ISBN 0 86463 179 0
©1990 Auckland City Art Gallery

| | |
|---|---|
| Director | Christopher Johnstone |
| Curator | Roger Blackley |
| Publication manager | Ronald Brownson |
| Designer | Philip McKibbin |
| Exhibition administrator | Priscilla Thompson |
| Registrar | Geraldine Taylor |
| Photographers | John McIver, Jennifer French |
| Conservation | Edward Kulka, Don Murchison |
| Framing | Jeremy Dart |
| Research assistance | Christina Barton |
| Marketing | Katherine McCulloch, Jennifer Balle |
| Education | Gillian Chaplin, Adrienne Pedder |
| Editorial services | Michael Gifkins Associates, Auckland |
| Typesetting | Graphics Corporate, Auckland |
| Printing | Academy Press, Auckland |

Additional photography
Brian Bird, Sydney, pp.12,13
Jane Dawber, Arc Photo, Dunedin, pp.25,30,34,37,57,65,72,92,107
Les Maiden, Wellington, pp.94,109
Christopher Matthews, Napier, p.73

# CONTENTS

# ACKNOWLEDGEMENTS

Auckland City Art Gallery thanks the directors, curators, registrars, conservators and photographic staff of the institutions which have generously lent works of art for the exhibition *Two Centuries of New Zealand Landscape Art*, 2 February - 22 April, 1990.

*United Kingdom*
National Maritime Museum, Greenwich

*Australia*
Art Gallery of New South Wales, Sydney
Art Gallery of South Australia, Adelaide
Mitchell Library, State Library of New South Wales, Sydney
National Library of Australia, Canberra
South Australian Museum, Adelaide

*New Zealand*
Alexander Turnbull Library, Wellington
Auckland Institute and Museum
Auckland Public Library
The Bath-House, Rotorua's Art and History Museum
Bishop Suter Art Gallery, Nelson
Bank of New Zealand Collection, Wellington
Canterbury Museum, Christchurch
Dunedin Public Art Gallery
Fletcher Challenge Collection, Wellington
The Fletcher Collection, Auckland
Hawke's Bay Museum, Napier
Hocken Library, Dunedin
National Art Gallery, Wellington
National Museum, Wellington
Otago Early Settlers Museum, Dunedin
Robert McDougall Art Gallery, Christchurch
Sarjeant Gallery, Wanganui
Waikato Museum of Art and History, Hamilton
Hamish Keith, and other private collectors who wish to remain anonymous

For permission to reproduce the works, we are greatly indebted to the artists and artists' estates.

# PREFACE

It is a nice coincidence that the foundation of the nation of New Zealand and of Auckland City occurred in the same year, 1840, so it is appropriate for me to introduce this picture book which has been conceived to mark the 150th anniversary of the signing of Te Tiriti o Waitangi, the Treaty of Waitangi, and the founding of Auckland.

The vigorous tradition of landscape is the bedrock of New Zealand's visual arts. This tradition began with Captain James Cook's artists some two hundred years ago, and continues on today as the 110 works illustrated in this book so clearly show.

The Auckland City Art Gallery opened in February 1888, and was the earliest permanent art museum in New Zealand. The Gallery has actively contributed to our awareness, knowledge and understanding of New Zealand art both through its permanent collection and through its exhibitions and the scholarship that accompanies them.

Almost half of the works of art illustrated in this book are in the Gallery's collection. The remainder are from public and private collections in New Zealand and overseas. They are selected from some 250 exhibits brought together for the Gallery's major exhibition for 1990.

I am delighted that this book, conceived for a wide readership in New Zealand and abroad, should mark the anniversaries of New Zealand and of Auckland and that it is also the first publication by the Gallery in its role as one of the Civic Enterprises of the newly constituted Auckland City.

Catherine A. Tizard
Mayor of Auckland City

# FOREWORD

This is an affordable, non-specialist but nonetheless scholarly picture book on landscape art in New Zealand. It is not a history of New Zealand art as such, rather a visual introduction or companion.

The book was conceived as Roger Blackley began preparing the exhibition of the same name and from which the works illustrated have been selected. Some of these pictures are already well known through frequent reproduction but others are reproduced here for the first time. Among the unique features of the book are the inclusion of photographic depictions within the tradition of New Zealand landscape art, the wealth of information provided in the commentaries, and the extensive bibliography related to the artists whose works are illustrated.

*Two Centuries of New Zealand Landscape Art* is the first independent publication of its kind to be published by the Auckland City Art Gallery. Art museums probably publish more art books than commercial publishers but it is less common, certainly in New Zealand, for museums to compete with commercial publishers by identifying a niche in the market and proceeding to fill it.

We trust that the book amply justifies the generosity of the many institutions and private collectors who gave us permission to reproduce their works and assisted us in so many other ways. Not every work lent to the exhibition could be reproduced here; the full list of lenders appears in the acknowledgements.

The Auckland City Art Gallery is pleased to acknowledge the assistance of a grant from the Queen Elizabeth II Arts Council of New Zealand towards Roger Blackley's research. We also acknowledge the continuing support of the Art Gallery Board of Auckland City, which enthusiastically endorsed the project for development, and the assistance of the Gallery staff: in particular Ronald Brownson, Senior Curator, Research Collections and Philip McKibbin, Graphic Designer, respectively manager and designer of the publication; and Photographer and Assistant Photographer John McIver and Jennifer French.

Christopher Johnstone
Director

# INTRODUCTION

This book grew out of my experience of selecting works for inclusion in an exhibition. The aim was to celebrate two centuries of landscape art, the most vigorous genre in the pakeha art tradition, by assembling around 250 items drawn from a broad range of pictorial media. Hence the exhibition embraces artists' prints and photographs as well as oil paintings and watercolours, amateur settler-artists in addition to professional artists, and unfamiliar pictures along with famous ones.

The book contains 110 plates, and therefore involves a further selection of works. The structure of the exhibition, in which groups of works by selected artists provide areas of focus, is preserved in the book by representing a number of artists with several reproductions. Regrettably, this means the necessary exclusion from the book of some very fine artists included in the exhibition. Included among noteworthy absentees are John Webber, Alfred Burton, J.C. Hoyte, Rata Lovell-Smith and John Weeks. Nevertheless, while it cannot claim to present a comprehensive history of landscape art in New Zealand, this picture book accurately reflects the essential nature and balance of the exhibition.

The commentaries seek to provide a context for the works of art by outlining the circumstances of their production, by illuminating aspects of the artists' careers, and (wherever possible) by allowing the artists to reveal their attitudes and intentions in their own words. Research for the commentaries led to a wealth of information hidden in periodicals, theses, and exhibition catalogues. Footnotes to quotations are in shortened form and refer to relevant entries in the bibliography, which is also accessible through the references provided beneath the plates.

Certain conventions govern the information presented in the captions. Artists' names are, as far as could be ascertained, their working names as artists. Hence Sir Tosswill Woollaston is here the artist M.T. Woollaston. The artists' original titles have been preferred, meaning that titles of works reproduced here sometimes differ from their usual form. Wherever possible, titles have been based on an inscription, but early exhibition catalogues and reviews have also provided invaluable evidence of artists' preferred titles. Original titles sometimes seem long by modern standards, but they provide essential information for viewing the pictures: the introductory what, where, and when.

Establishing the date of a work of art is frequently problematic, as the date of production can differ from the date of the original sketch or depicted event. A *circa* date has been assigned to those works without secure dates. These have been established with the help of artists' writings, contemporary catalogues and reviews, and from clues scattered throughout the extensive literature on New Zealand art. The nature of a *circa* date is that it must be provisional.

Many of the great works now in New Zealand public collections are gifts from artists, artists' families and friends, collectors, and the descendants of artists and collectors. The identity of the donor is essential information which should always appear in a caption, although this is frequently not the case. Every attempt has been made to establish correct details. In the event of any oversight, Auckland City Art Gallery would appreciate the information.

Roger Blackley
Curator, Historical New Zealand Art

# PLATES AND COMMENTARY

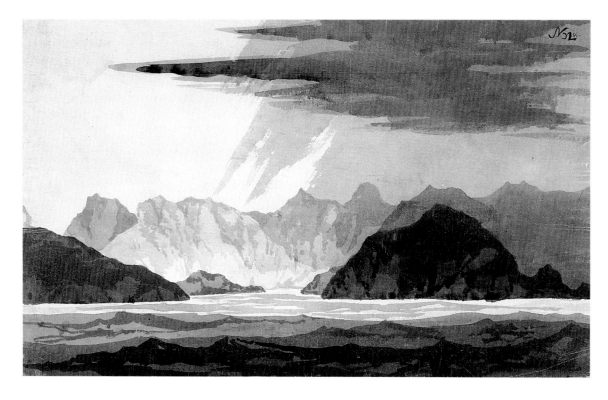

While Sydney Parkinson and others produced sepia landscape drawings on Captain James Cook's first visit in 1769, it was the classically trained landscape artist William Hodges on Cook's second voyage whose watercolours mark the first response to the atmospheric and climatic realities of the New Zealand landscape. *In Dusky Bay* was made as the *Resolution* reached south-west New Zealand on 26 March 1773 after an exhausting four-month voyage through Antarctic waters. The relief and elation provoked by the sight of land and the accompanying milder weather was expressed by all, but by none as effectively as Hodges in this luminous watercolour. The following morning, before the ships sailed further into Dusky Sound, Hodges made another watercolour of the same scene. This time he showed a limpid sunrise, with the spectacular range of mountains thrown into silhouette.[1]

*The north entrance* was made as the ship left Dusky Sound a month and a half later. The monochromatic nature of this drawing relates to Hodges's dwindling supply of watercolours, but as in the coloured works he used broad brushstrokes to depict clouds and their interaction with the hills below. Hodges was friendly with William Wales, astronomer and meteorologist on the *Resolution*, who may have strengthened the artist's interest in the capricious mobility of the New Zealand skies. Although the effect is radically unlike the careful topographical drawings produced on the first voyage, Cook was delighted and wrote in his *Journal*, "Mr Hodges has drawn a very accurate view both of the North and South entrance as well as several other parts of this Bay, and in them hath delineated the face of the country with such judgement as will as once convey a better idea of it than can be expressed by words."[2]

1 reproduced in Keith 1983, p.29.
2 quoted in Joppien & Smith 1985, p.143.

William HODGES   (1744-1797)
*The north entrance to Dusky Bay*  11 May 1773
watercolour, 220 x 330 mm
Mitchell Library,
State Library of New South Wales, Sydney

William HODGES   (1744-1797)
*In Dusky Bay, New Zealand*  26 March 1773
watercolour, 382 x 543 mm
Mitchell Library,
State Library of New South Wales, Sydney

HODGES:  BEGG 1966, 1970;  COLLINS 1979,  JOPPIEN 1976;  JOPPIEN & SMITH 1985;  KEITH 1983;  MURRAY-OLIVER 1959, 1969;  POUND 1983a;  STUEBE 1979;  TOMORY 1964.

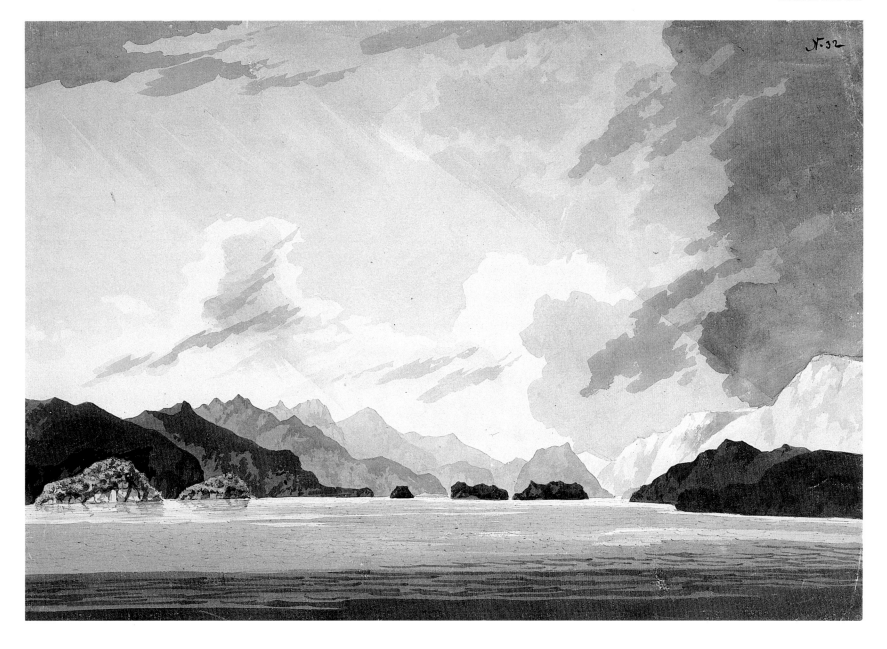

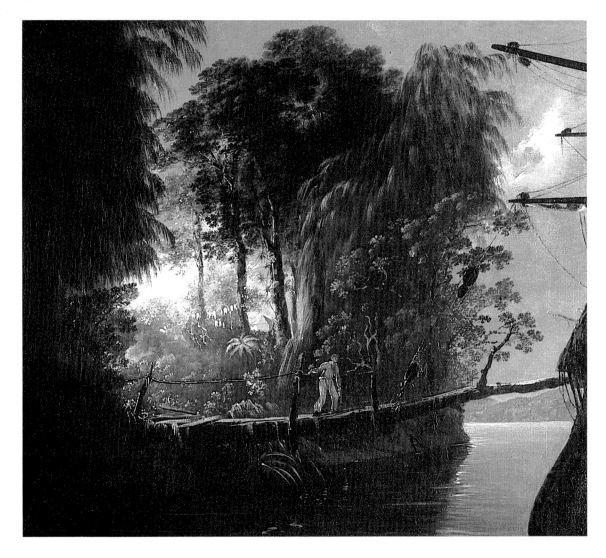

William HODGES (1744-1797)
*View in Pickersgill Harbour, Dusky Bay, New Zealand*
April 1773
oil on canvas, 654 x 731 mm
National Maritime Museum, Greenwich, London,
on loan from Ministry of Defence

William HODGES (1744-1797)
*Cascade Cove, Dusky Bay* 1775
oil on canvas, 1346 x 1911 mm
National Maritime Museum, Greenwich, London,
on loan from Ministry of Defence

*View in Pickersgill Harbour* must be the earliest oil
painting executed in New Zealand. From the rear of the
ship Hodges depicts a sailor crossing the natural
gangplank with a fish he has just cooked over a fire.
Beyond is the clearing hacked from the primeval forest
by William Wales and his assistants, in order to house
the astronomer's tent and to provide a clear sky for
observations which would help to fix New Zealand's
position on the globe. The observatory was finally
erected on 2 April, but the presence of washing strung
between the trees suggests that the painting was finished
after 11 April, when Cook records the arrival of serene
weather suitable for drying the ship's linen.

On 12 April Cook recorded an important excursion.
"Being a fine afternoon I took Mr Hodges to a large
Cascade which falls down a high mountain on the South
side of the Bay... He took a drawing of it on Paper and
afterwards painted it in oyle Colours which exhibits at
one view a better description of it than I can give..."[1]
This large canvas was made after Hodges had returned
to London, a fusion of his representation of the waterfall
with the sketches of the Kati Mamoe family he had
made five days earlier on Indian Island. Here is New
Zealand translated into the language of Edmund Burke's
sublime: a lonely Maori family posed against gloomy
forests, a vast cataract shimmering under a rainbow.

1 quoted in Joppien & Smith 1985, p.23.

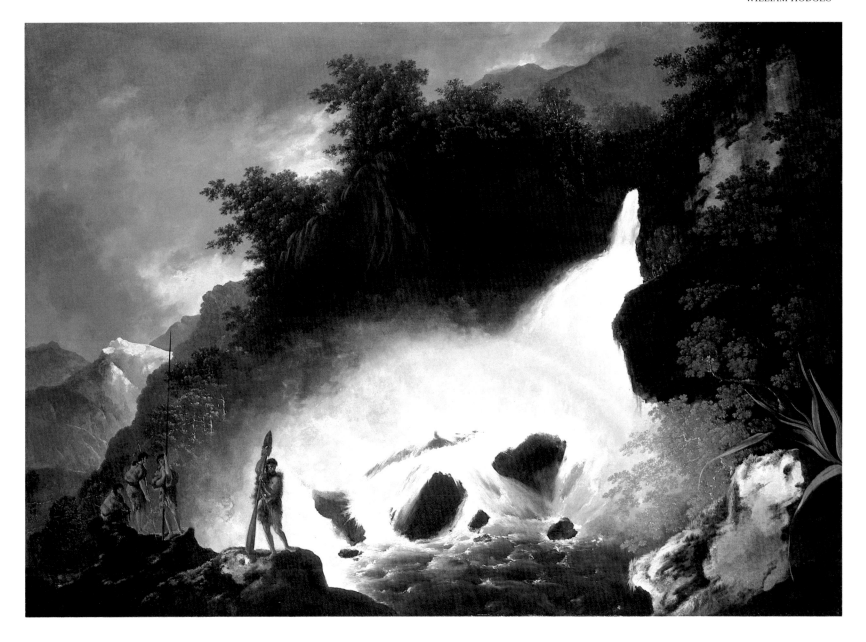

Augustus EARLE   (1793-1838)
*The Wye Matte, a waterfall near the Kiddy Kiddy*  1827-28
watercolour, 378 x 257 mm
Rex Nan Kivell collection,
National Library of Australia, Canberra

Augustus EARLE   (1793-1838)
*Scene in Parua Bay, Bay of Islands*  1827-28
watercolour, 210 x 327 mm
Rex Nan Kivell collection,
National Library of Australia, Canberra

Augustus EARLE   (1793-1838)
*Parua Bay, Bay of Islands, New Zealand*  1827-28
watercolour, 210 x 324 mm
Rex Nan Kivell collection,
National Library of Australia, Canberra

EARLE:  DOCKING 1971; EARLE 1832, 1838; HACKFORTH-JONES 1980, 1984; KEITH 1983; MURRAY-OLIVER 1953, 1968, 1971; POUND 1982, 1983a; SCHOLEFIELD 1940; SMITH 1960.

Augustus Earle's gregarious nature was perfectly suited to his profession as the first freelance travel artist to tour the world. He was also the first European artist to take up residence in New Zealand, from November 1827 to April 1828, where he horrified missionaries at the Bay of Islands by befriending and living with his "pagan" hosts. Earle's watercolours and drawings of landscapes and Maori life and culture in 1827-28 are among the greatest treasures of early New Zealand art. In addition, his *Narrative of a Residence in New Zealand*, first published in 1832, is one of the liveliest of all contributions to the country's pre-colonial literature. A manuscript list accompanying the watercolours now in Canberra provides evidence that Earle planned to publish a *Voyage Round the World*, which his sequence of watercolours was perhaps intended to illustrate.

Before the majestic backdrop of Waimate Falls near Kerikeri, the artist has depicted himself in conversation with a Maori chief. Earle's New Zealand watercolours are executed in a limited and subdued range of colours, still essentially in the eighteenth-century tradition of the tinted drawing within which William Hodges was operating. Surviving both a fire that destroyed his Kororareka dwelling and subsequent looting by Maori, as well as the depredations of time, these on-the-spot sketches of 1827-28 still retain an astonishing freshness.

Paroa Bay, on the southern approach to the Bay of Islands, has changed little since Earle's visit. It is still accessible only by sea, and ancient pohutukawa preside over a beautiful reef. These watercolours show how Earle's hosts liked to relax at the beach, with liquid refreshment close at hand in the gourd carefully placed on a rock. Earle is clearly also interested in the extraordinary shapes formed by the trees, contorted over centuries but still very much alive.

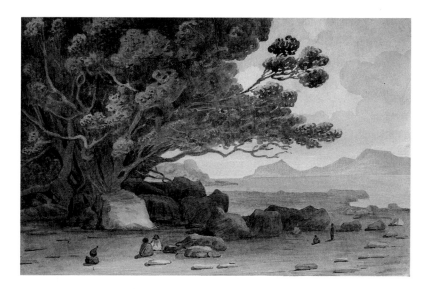

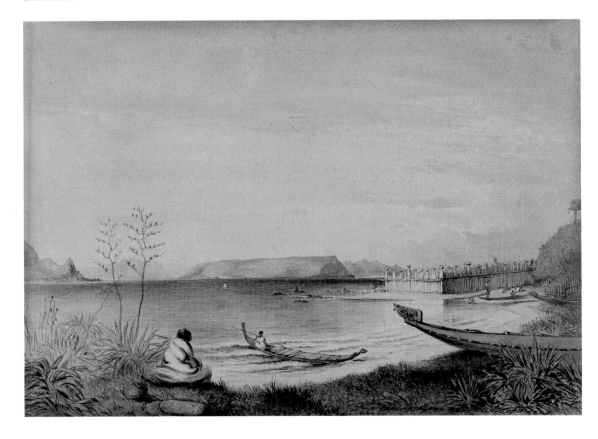

George French ANGAS   (1822-1886)
*Rangihaeata's pah, with the Island of Mana and the*
*opposite shores of Cook's Straits*  1844
watercolour, 232 x 339 mm
Art Gallery of South Australia, Adelaide,
bequest of J. Angas Johnson, 1902

Augustus EARLE   (1793-1838)
*The meeting of the artist and the wounded chief Hongi at*
*the Bay of Islands, November 1827*  c.1835
oil on canvas, 900 x 595 mm
Alexander Turnbull Library, Wellington

Hongi Hika, the Ngapuhi warrior chief whose "musket wars" of the 1820s devastated tribal foes to the south, was himself critically wounded in January 1827. He had been forced to fight without his coat of mail, given to him along with his first muskets by King George IV in 1821 while on a visit to England. Plagued by Job-like afflictions, Hongi arrived at the Bay of Islands in November 1827. Hurriedly employing an interpreter, Earle hastened to pay homage to the great chief, who allowed him to make his likeness. The oil painting depicting this interview was made in London, towards the end of Earle's life, and incorporates a wealth of details derived from his sketches. Earle presents himself as the focus of attention, the raconteur on whom almost all eyes are turned. Littered about the landscape are the prized possessions of contemporary Maori culture, a wealth of muskets and traditional carvings. Long recognised as one of the most important paintings of the pre-colonial period, *The meeting* has suffered considerably from unsympathetic restoration. Nevertheless, the drama of the encounter, one of the great moments in Earle's career, remains unimpaired.

Another indefatigable travel artist, George French Angas produced hundreds of watercolours during a six-month trip in 1844. Angas was intensely interested in all aspects of Maori culture, depicting outside kitchens as well as carved meeting houses, burial monuments along with general views of Maori settlement, and many portraits. This view is of Ngati Toa's fortified pa at Porirua, built following the bloodshed at Wairau during protests over the surveying of unsold land. *Rangihaeata's pah* appeared as one of the plates in Angas's popular series of lithographs, *The New Zealanders Illustrated*, published in London in 1847. Angas's father was the founder of Adelaide, where the bulk of this important artist's watercolour output is now held in the collection of the South Australian Museum and the Art Gallery of South Australia.

ANGAS: ANGAS 1847a, 1847b; DOCKING 1971; KEITH 1983; REED 1979a, 1979b; SCHOLEFIELD 1940; TREGENZA 1980.

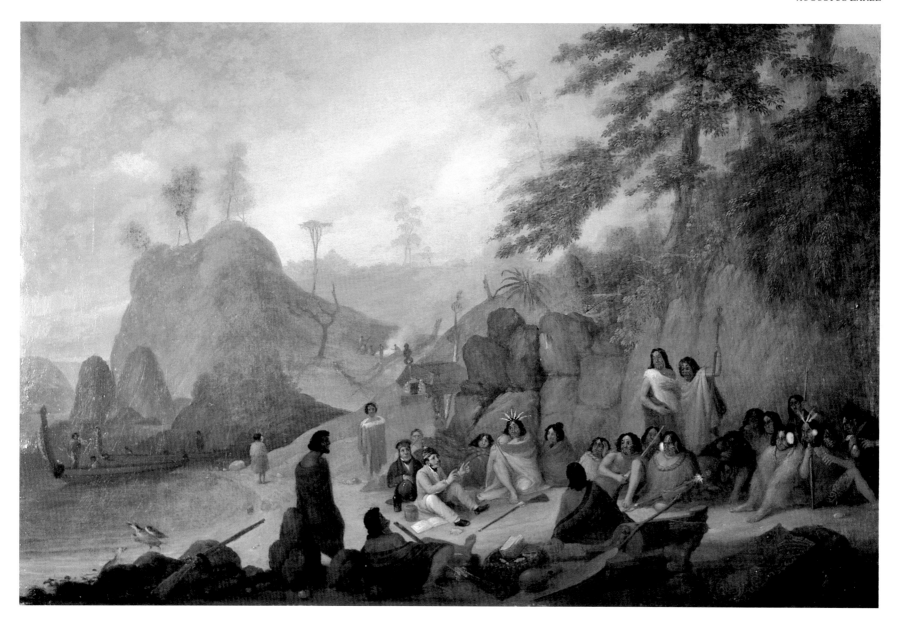

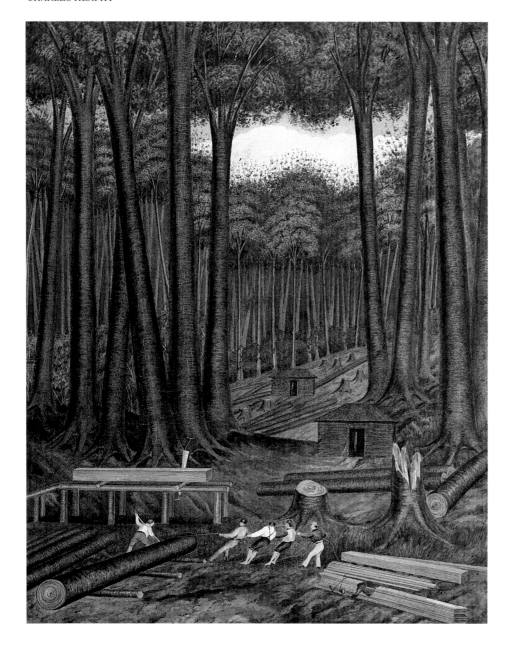

Charles HEAPHY (1820-1881)
*Kauri forest, Wairoa River, Kaipara* December 1839
watercolour, 475 x 380 mm
Alexander Turnbull Library, Wellington

Charles HEAPHY (1820-1881)
*View of the Kahu-Kahu, Hokianga River* December 1839
watercolour, 307 x 430 mm
Alexander Turnbull Library, Wellington

Nineteen-year-old Charles Heaphy arrived in New Zealand in August 1839, employed as artist and draughtsman to the New Zealand Company. This famous depiction of sawyers working in a majestic kauri forest was made later that year during an exploratory trip to the Kaipara and Hokianga. Sometimes mistakenly characterised as "primitive", Heaphy's highly detailed watercolours were probably worked up on board the *Tory* from sketches made on the spot. Here Heaphy provides an invaluable record of one of the country's oldest industries, one which was destined to change forever the landscape of the North. It was chosen for one of the lithographs published in 1845 to accompany Edward Jerningham Wakefield's *Adventure in New Zealand*, in a portfolio of pictorial propaganda intended to encourage colonisation.

In December 1839 Wakefield described a visit to G.F. Russell's establishment at Kohukohu. "Two or three miles above the Narrows, and twenty-six miles from the river's mouth, we anchored close to two other barques which were loading *kauri* timber for New South Wales. On the bank to our left was the house and store of a timber dealer and general store-keeper."[1]

1 Wakefield 1845, vol.1, pp.149-150. For an account of the persistent scholarly misrepresentation of Kohukohu as Horeke see Lander 1989.

HEAPHY: BROWN & KEITH 1969; DOCKING 1971; GORDON & STUPPLES 1987; HEAPHY 1842; KEITH 1983; LANDER 1989; McCORMICK 1949; MURRAY-OLIVER 1972, 1981; POUND 1983a; SCHOLEFIELD 1940; STANDISH 1966; TAYLOR 1959.

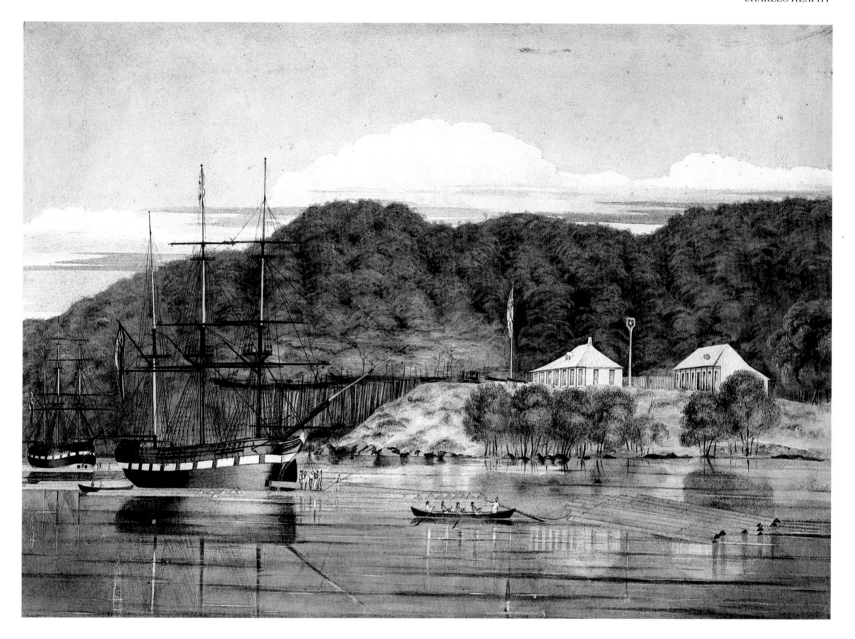

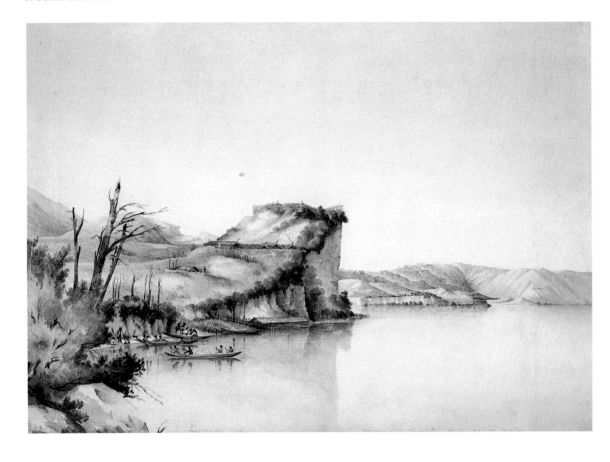

J. Guise MITFORD   (1822-1854)
*Tarawhera lake, Tauaroa pah, Whareroa pah in the distance* 1844-45
watercolour, 359 x 512 mm
Alexander Turnbull Library, Wellington

John WILLIAMS   (active NZ 1845-46)
*H.M.S. North Star, destroying Pomare's pa Otuihu, Bay of Islands* 1845
watercolour, 202 x 278 mm
Alexander Turnbull Library, Wellington

When free trade was declared in the Bay of Islands in October 1844, customs official John Guise Mitford found himself out of work. After negotiating full pay for the remainder of the year, the adventurous Mitford set out on a journey to the silica terraces of Rotomahana in the interior of the North Island, natural wonders recently described by the New Zealand Company explorer Ernst Dieffenbach.[1] This is the largest of the watercolours Mitford made on that trip, a view of a lakeside pa of the Tuhourangi, reflected in the glassy waters of Lake Tarawera on a midsummer day. Mitford was particularly interested in Maori culture, and his careful and assured watercolour reveals a mass of important details such as the unusual sloping tekoteko (gable figures) on these houses. Soon this community was to welcome an American missionary, Seymour Mills Spencer, who was responsible for the English-style "model village" of Te Wairoa from which tourists left to visit the terraces until the 1886 eruption of Tarawera changed everything.

Lance-Sergeant John Williams and his commander Major Cyprian Bridge, of the 58th Regiment, are New Zealand's earliest military topographers. This stark depiction of the destruction of Pomare's pa on 30 April 1845, effectively a reprisal for the sack of Kororareka a month and a half earlier, has long been ascribed to Bridge. Not only is Bridge's loose watercolour style quite antithetical to Williams's careful miniaturism (every rope, every man depicted), but as commander of a tricky operation Bridge simply could not have made this view from the other side of the Kawakawa inlet. Bridge's diary contains a description of the "laughable scene" within the captured pa, with "officers and men running after pigs, turkeys, ducks and goats, shooting and cutting off their heads with their swords."[2] Bridge managed to souvenir a small rifle and a "native war club" before flames engulfed the pa, when he supervised the embarkation of his men until 9 pm.

1 Dieffenbach 1843, vol.1, pp.381-385. For a similar trip by another artist see Johnson 1847.
2 Bridge MS, vol.1, p.10. For an account of just how "tricky" this operation was, see Merrett 1845.

MITFORD: BLACKLEY 1983; KEITH 1983; LOCKE & PAUL 1989; PLATTS 1980.

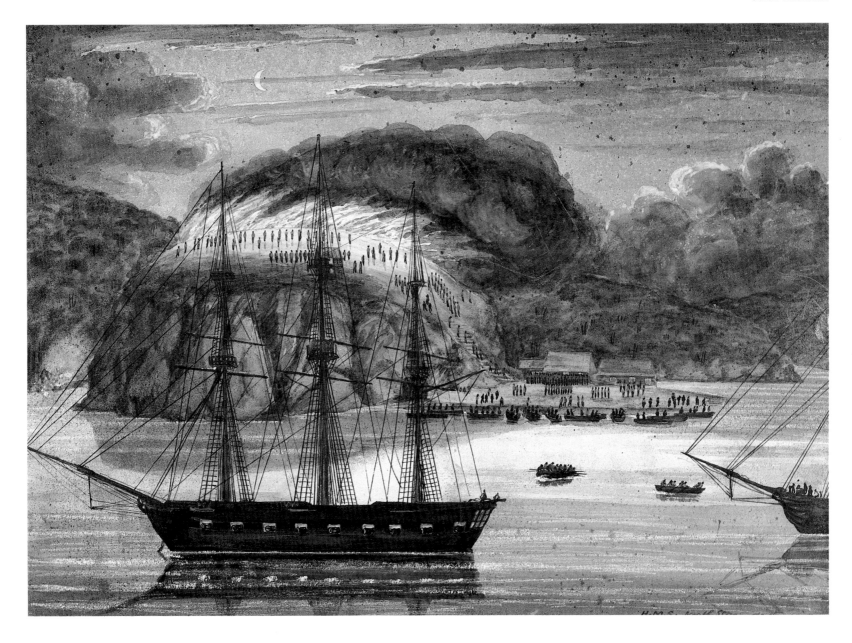

WILLIAMS, JOHN: BLACKLEY 1984; BRIDGE MS; COWAN 1983; MERRETT 1845; PLATTS 1980.

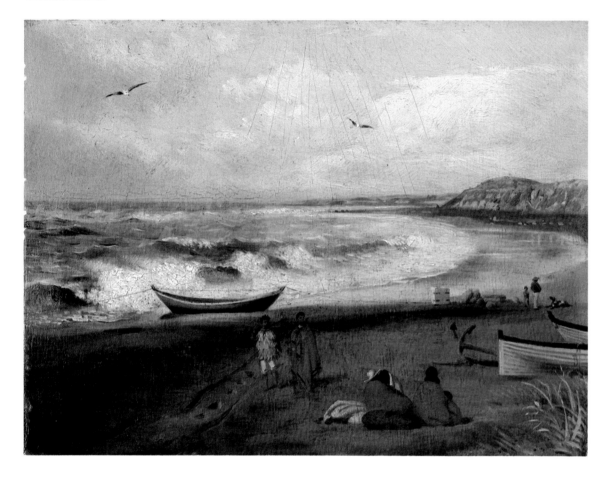

William STRUTT (1825-1915)
*Beach at Taranaki, New Zealand* 1855
oil on panel, 130 x 175 mm
Rex Nan Kivell collection,
National Library of Australia, Canberra

J.A. GILFILLAN (1793-1863)
*Maori korero, native council deliberating on a war expedition* 1853
oil on canvas, 955 x 1270 mm
Hocken Library, Dunedin

John Alexander Gilfillan had been Professor of Painting at Glasgow's Andersonian University for eleven years before he emigrated with his family in 1841 to the New Zealand Company colony of Wanganui. There they built a town house, as well as establishing a farm in the Matarawa Valley. On 18 April 1847, in reprisal for a possibly unrelated incident, a Maori war party destroyed the farm house, killing Gilfillan's wife and three of their children. Gilfillan moved on with three surviving children to work as an artist in Sydney, Adelaide and from 1852 in Melbourne. He was one of the founders of the Victorian Society of Fine Arts, and this ambitious history painting, set in pre-European New Zealand, was doubtless aimed at helping to secure his reputation as one of Melbourne's leading painters, alongside Eugene von Guérard and Nicholas Chevalier.

William Strutt had been working as an artist and illustrator in Melbourne for five years before his arrival in New Plymouth with his wife and child on 27 March 1855. He described it as "a poor and uninviting place, indeed hardly worthy of the name of a town, having but two straggling streets…"[1] Disembarkation was not easy. "New Plymouth at this time had no harbour, being an open roadstead, thus vessels had to ride at anchor about half a mile out at sea, their passengers, luggage and cargo, were therefore landed by large surf boats - a not very convenient fashion, as lady passengers were carried ashore in the arms of the boatmen and the men on their backs." Painted as a personal memento, showing a settler with his luggage dumped ignominiously on the beach, this is a rare example of an outdoor oil sketch by one of the most proficient of all artists to visit nineteenth-century New Zealand.

1 Mackaness 1958, vol.2, p.2.

STRUTT: CURNOW 1979, 1980a, 1980b; DOCKING 1971; MACKANESS 1958.

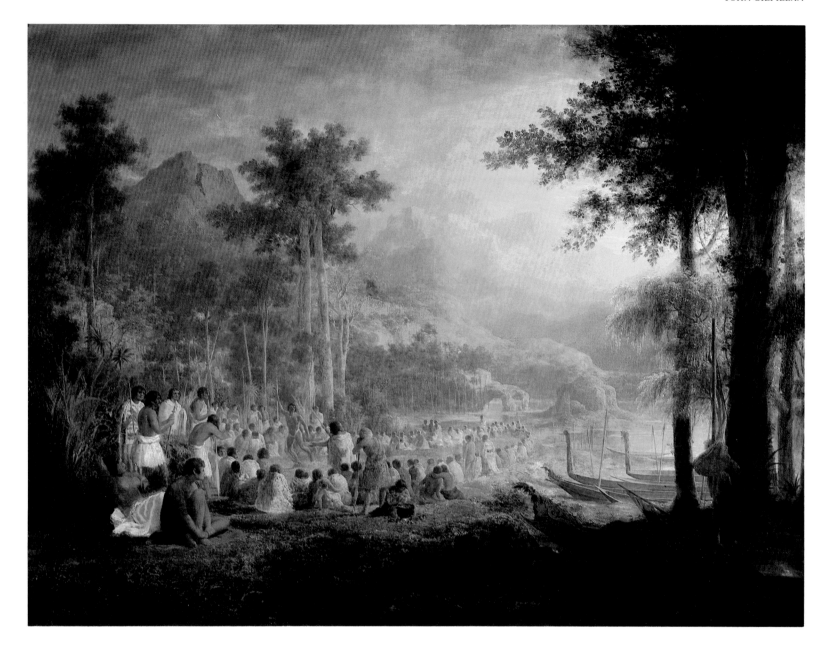

GILFILLAN: DOCKING 1971; FRAME 1984; POUND 1983a; SCHOLEFIELD 1940.

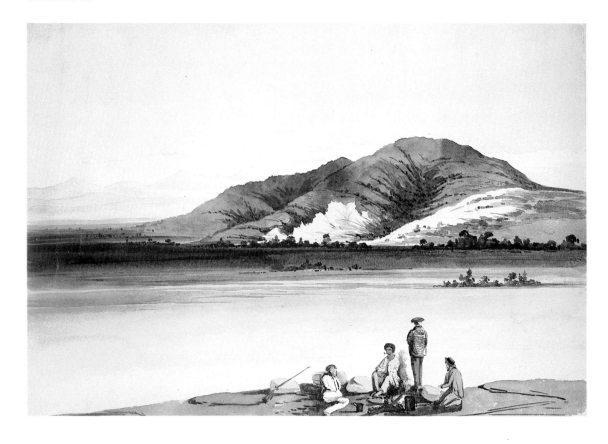

William FOX (1812-1893)
*On the grass plain below Lake Arthur* 8 & 9 February 1846
watercolour, 243 x 350 mm
Alexander Turnbull Library, Wellington

William STRUTT (1825-1915)
*Burning the bush, Taranaki* 1856
pencil and watercolour on grey paper, 199 x 298 mm
Alexander Turnbull Library, Wellington

William Fox's distinguished career as a politician was based on his early involvement with the New Zealand Company, for whom he made an exploration of the Wairarapa in 1843. He was rewarded with the post of resident agent in Nelson, replacing Arthur Wakefield who was killed in the affray at Wairau. In February 1846 Fox set out on a journey into the Nelson hinterland, this time in the company of Thomas Brunner, Charles Heaphy and Kehu, a Maori guide. Compared with Brunner's subsequent marathon exploration of the West Coast, this trip was more like an extended picnic. Heaphy took care of potting the birds, leaving Fox to record the scene for the benefit of the New Zealand Company directors. The expert sketches made on this trip are among Fox's most celebrated works, the first evocation of a landscape soon to experience a pastoral invasion.

William Strutt's drawings, together with his later autobiographical account of an attempt to settle in New Zealand, are among the most vivid accounts of the arduous business of carving a farm out of the primeval forest. On first encountering the bush, Strutt and an Australian friend were astonished by this "uncanny region", rhetorically asking "where will not the Anglo-Saxon penetrate?"[1] Strutt's was a romantic attachment to "the mysterious dark recesses of the Creator's sublime work… a programme of delights which I suppose were some of the secret drawings so powerful to an imaginative mind."[2] Strutt's ecstasy was short-lived. The desolation of life buried in the bush, "walled in by the mighty forest and shut out from all human intercourse", led the artist and his family to abandon the hard-won clearing with its fern-tree house and to return to New Plymouth and then, eighteen months after leaving, back to Melbourne.

1 Mackaness 1958, vol.2, p.3.
2 ibid., p.7.

FOX: BROWN & KEITH 1969; DOCKING 1971; FOX 1851; KEITH 1983; MORRELL 1966; POUND 1983a; SCHOLEFIELD 1940; SOTHERAN 1978; TAYLOR 1959.

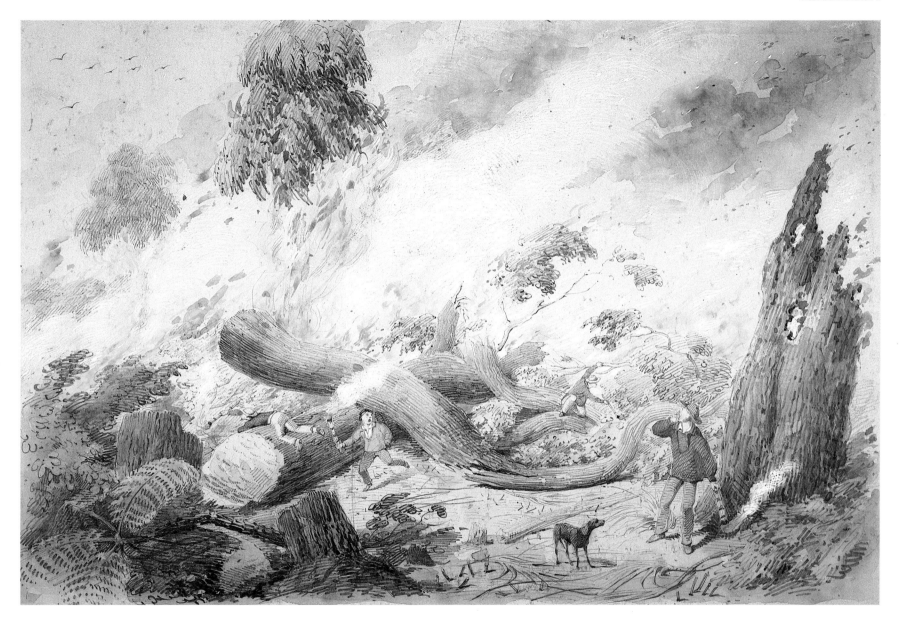

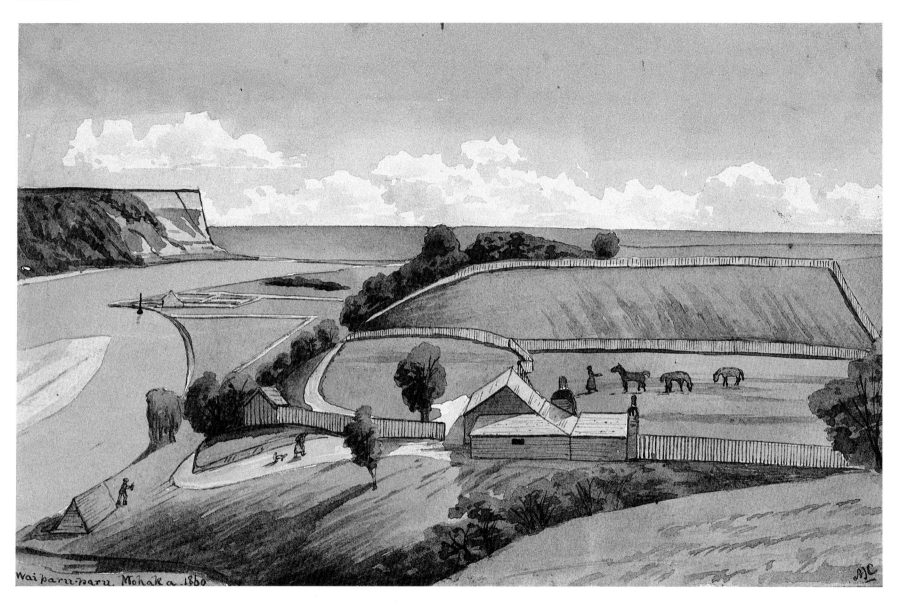

Wai paru-paru. Mohaka 1860

COOPER : BELICH 1986; COWAN 1922; MURRAY-OLIVER 1980.

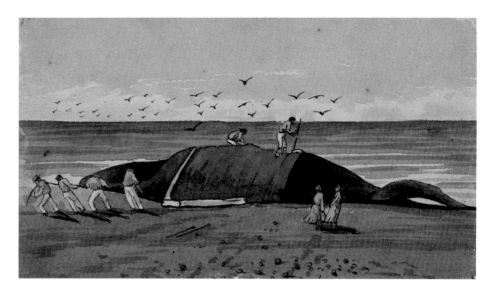

A.J. COOPER   (active 1855-1869)
*Waiparu-paru, Mohaka*  1860
watercolour, 145 x 229 mm
Alexander Turnbull Library, Wellington,
presented by Mr and Mrs W.J. Mouton, 1969

A.J. COOPER   (active 1855-1869)
*Cutting the blubber off a whale on Mohaka beach*  c.1860
watercolour, 72 x 130 mm
Alexander Turnbull Library, Wellington,
presented by Mr and Mrs W.J. Mouton, 1969

A.J. COOPER   (active 1855-1869)
*Bushwork. Crosscutting timber in Lavin's bush*  c.1860
watercolour, 75 x 130 mm
Alexander Turnbull Library, Wellington,
presented by Mr and Mrs W.J. Mouton, 1969

When Te Kooti's war party descended on Mohaka on 10
April 1869, among those killed were Alfred John Cooper,
Cooper's friend John Lavin, and Lavin's wife and
children. Years earlier, Lavin had sent a series of
Cooper's watercolour sketches back to his family in
England. These are exquisite depictions of collaborative
pioneering work in which there is no shadow whatsoever
of the tragedy to come.

Cooper and Lavin were among the earliest settlers to
take up land in the Mohaka. Cooper documented their
tent-life of the "first day of settling" in September 1855,
and the following year produced a wonderful interior
depiction of Lavin's first Maori-built house. In *Cutting
the blubber* he contributes a rare picture of such an
activity in New Zealand, and Lavin in his text on the
reverse notes "That Whale made about 12 tons of oil".
On the reverse of *Bushwork*, Lavin wrote "Bushwork.
Crosscutting timber in Lavin's Bush for Rails, that's the
job I am at present occupied about. I was at work at it
today. I get my neighbour Mr Cooper to help me to
crosscut. The felling and splitting I do single handed. My
neighbour Cooper is facing you, very like him. My back
towards you. John Lavin. Rover on top the log."

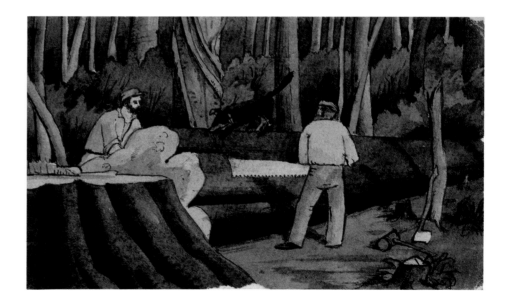

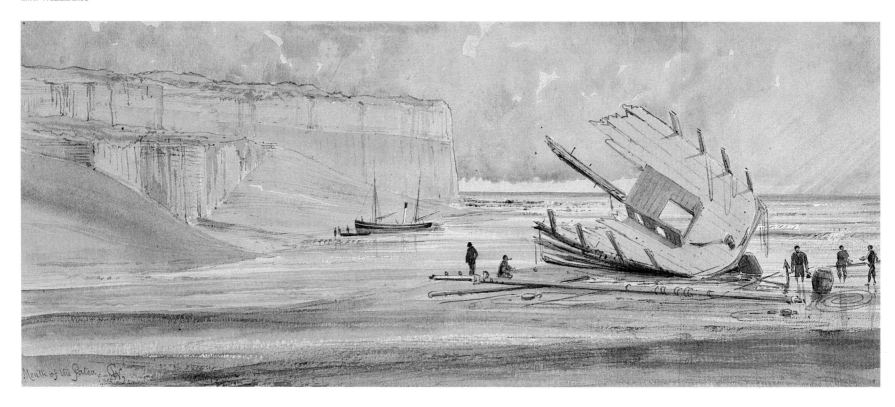

E.A. WILLIAMS   (1824-1898)
*Mouth of the Patea*  22 April 1865
pencil, watercolour and opaque white, 137 x 332 mm
Hocken Library, Dunedin

John SYMONS   (c.1832-1897)
*Maori group by a river*  c.1865
watercolour and opaque white, 400 x 530 mm
Auckland City Art Gallery, purchased 1989

Lieutenant-General Edward Arthur Williams was in New Zealand for two years, 1864-66. When he arrived there were 9,000 imperial troops already serving there, with 3,000 reinforcements on the way from India and England. This army was assisted by around 5,000 local militia and volunteers. Many officers were skilled watercolourists, but none can compare with E.A. Williams, who produced some of the best pictorial records of the Waikato and Taranaki campaigns. This drawing was made while the supply ship *Moa* was stranded for 36 hours. On the reverse of the painting Williams has noted "The Patea River is all very well when you've got in, but the approach is rather awkward at times." In the foreground are the remains of the *Alpha* from Melbourne, wrecked only a fortnight earlier.

A keen amateur artist, John Symons was one of the founders of the Auckland Society of Artists formed in 1869, the earliest such group in the country. He exhibited frequently, but surviving works are rare. This watercolour from early in his career is imbued with a naive realism. Symons's primary concern is the depiction of a unique landscape, virtually a catalogue of indigenous vegetation, and the clothing and characteristics of the Maori group. A delightful detail is the pet baby pig one of the women is holding under her arm.

WILLIAMS, E.A.: DOCKING 1971; MURRAY-OLIVER 1980.

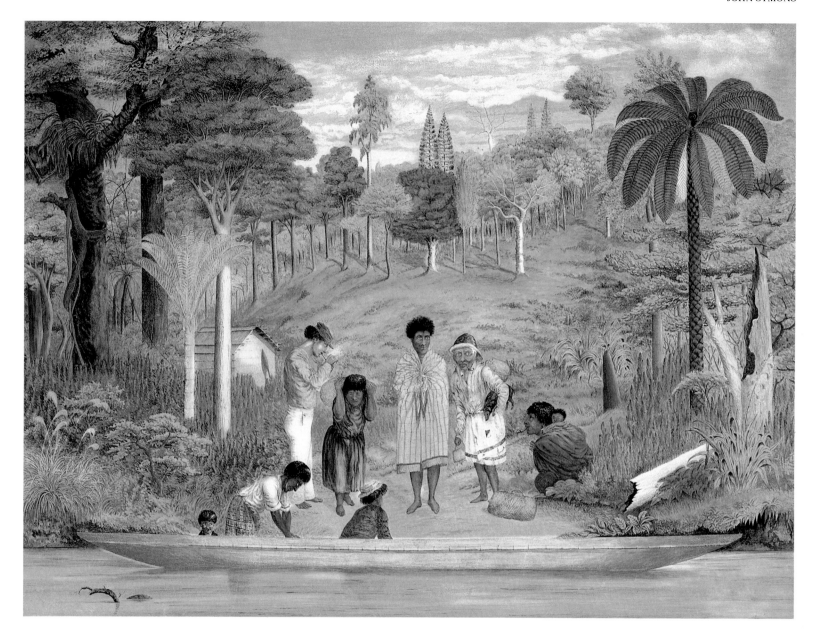

SYMONS: PLATTS 1980.

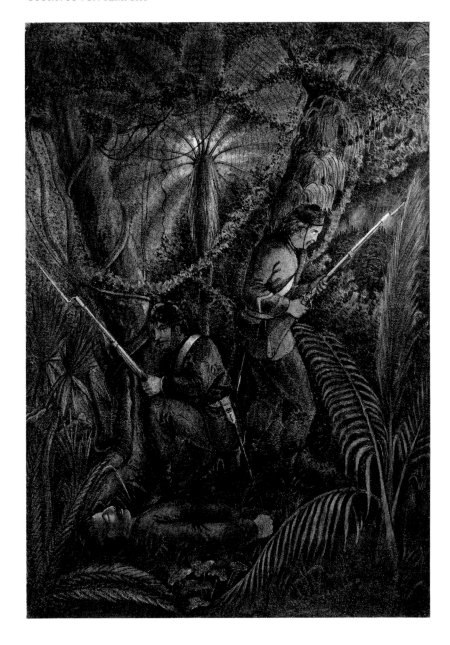

Gustavus von TEMPSKY   (1828-1868)
*Two men of the 65th Regiment guarding the body of an officer, natives' camp fires over in right, 1863*  c.1866
watercolour and gum arabic, 250 x 178 mm
Auckland Institute and Museum

William STRUTT   (1825-1915)
*An ambush, New Zealand, 1859*  c.1867
oil on canvas, 290 x 430 mm
Private collection, Auckland

Von Tempsky depicts the aftermath of an early engagement of the Waikato war, on 7 September 1863. Two men guard the body of their fallen commander, Captain Swift. In his memoir of the war, von Tempsky evoked the threatening atmosphere of that endless night in the bush near Tuakau. "They passed that night in the forest — the fires of the Maoris half lit up their refuge — they could hear the saturnalia of the victorious and the lamentations over the slain — and those noble men flinched not, but remained with their still charges till the following day brought an end to their dreadful suspense."[1]

Strutt's depiction of Maori ambushing British troops was made after the artist's return to England in 1862, and was exhibited with the Society of British Artists in 1867. While von Tempsky also painted Maori spying on settlers and soldiers, his rather stiff watercolours lack the drama of Strutt's work. Strutt's classical training at the Ecole des Beaux-Arts in Paris, and in the studios of leading French history painters of the 1840s, meant that he was both highly skilled in depicting the figure and also keenly aware of the pregnant psychological moment which makes for a successful history painting.

1 Von Tempsky MS, quoted in Young, Curnow & King 1981, p.246.

VON TEMPSKY: BELICH 1986; BELL 1978, 1981; DOCKING 1971; JONES 1966; SCHOLEFIELD 1940; YOUNG & MURRAY-OLIVER 1978.

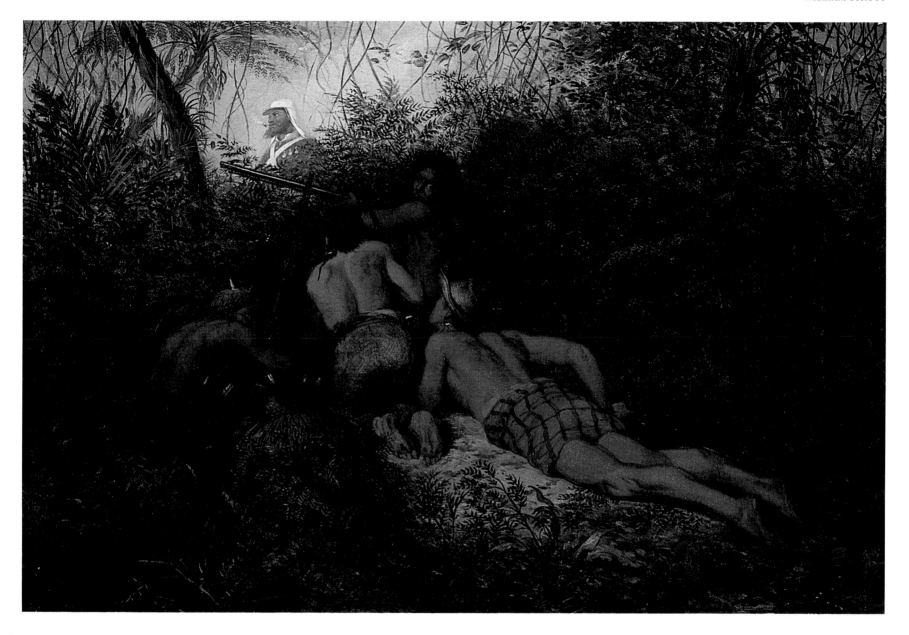

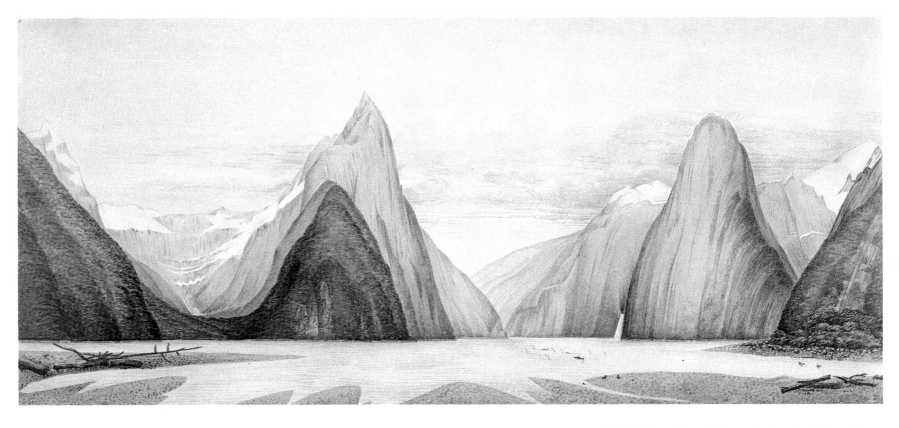

John BUCHANAN   (1818-1898)
*Milford Sound, looking north-west from Freshwater Basin*
1863
watercolour, 222 x 509 mm
Hocken Library, Dunedin

J.C. RICHMOND   (1822-1898)
*Lagoon, Grey River*  1862
watercolour, 240 x 338 mm
National Art Gallery, Wellington,
presented by Esmond Atkinson, from the estate of
D.K. Richmond, 1935

J.C. RICHMOND   (1822-1898)
*Te Reinga falls on the Wairoa, Hawke's Bay*  1867
watercolour and opaque white, 352 x 252 mm
National Art Gallery, Wellington,
presented by Esmond Atkinson, from the estate of
D.K. Richmond, 1935

John Buchanan's reputation rests almost solely on this monumental drawing of Milford Sound, executed on a survey trip to Otago and the West Coast. It was exhibited with other drawings by Buchanan in the 1865 New Zealand Exhibition, alongside the Province of Otago's geological specimens, and received an honorary certificate in the class devoted to "Educational works and appliances."[1] Buchanan's austere style harks back to the eighteenth-century method of drawing in neutral tints, and as the work of a surveyor and draughtsman would have been regarded by his contemporaries as technical drawing rather than as art. In the twentieth century, beginning with his inclusion in the 1940 National Centennial Exhibition, Buchanan has achieved canonical status as one of the greatest artists in New Zealand's topographical tradition.

BUCHANAN: COLLINS 1979; COLLINS & CURTIS 1988; COLLINS, GARRITY & ENTWISLE 1988; CURNOW 1989; DOCKING 1971; HAMLIN 1966; POUND 1983a; SCHOLEFIELD 1940.

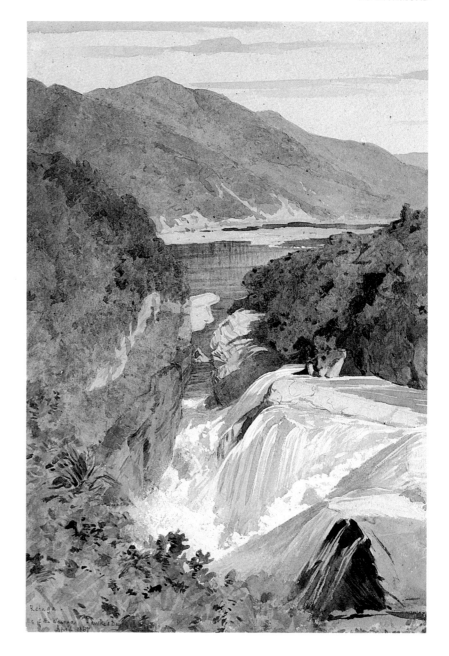

By training a civil engineer, James Crowe Richmond was Commissioner of Crown Lands from 1862 to 1865 in the Nelson Province, an area which then included Marlborough and Westland. He travelled extensively on horseback, on foot, and by sea, producing a body of atmospheric watercolours which, "made against time", frequently include expanses of bare paper. Some of the most magical of these drawings date from a visit to Greymouth early in 1862.

Having entered parliamentary politics, Richmond acted as Native Minister from 1866 to 1869, during the campaigns against Hauhau forces under Titokowaru and Te Kooti. Te Reinga, in the hills above Wairoa, was one of the many skirmishing sites of a protracted guerrilla war which began with Te Kooti's return from exile in 1868 and continued until 1872. This watercolour was made on one of Richmond's long journeys to hear Maori land grievances.

1 Collins & Curtis 1988, pp. 38-39.

RICHMOND, J.C.: ATKINSON 1932; BAGNALL 1966; COLLINS 1979; DOCKING 1971; HOCKEN LIBRARY 1966; McCAHON 1957; MACLENNAN 1961; OLIVER 1963; PLATTS 1983; SCHOLEFIELD 1940, 1960.

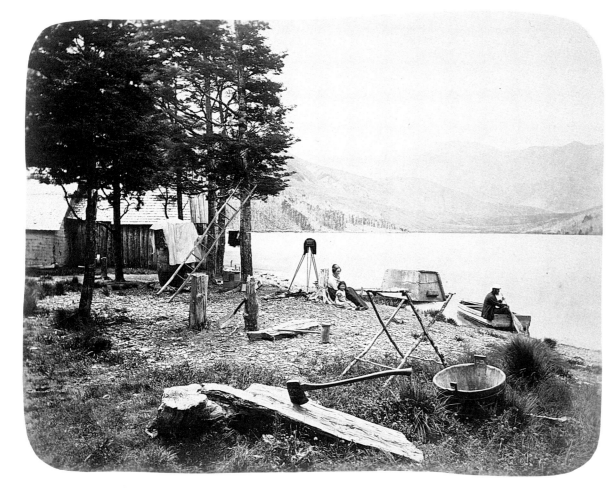

W.T. Locke TRAVERS (1819-1903)
*Travers's station* c.1865
albumen silver photograph, 155 x 204 mm
Auckland City Art Gallery, purchased 1986

John KINDER (1819-1903)
*Cliffs, Whangaparaoa, near Auckland* c.1868
albumen silver photograph, 233 x 292 mm
Hocken Library, Dunedin,
presented by Olga McCurdie, 1922

Long recognised as one of the great topographical watercolourists of the colonial period, John Kinder has also been claimed as an important pioneer by historians of photography. However, it is only recently that the full extent and nature of Kinder's extraordinary pictorial output has been revealed.[1] Of over 800 surviving pictures, almost half are photographs, which for an amateur is a truly prodigious output. Kinder's amateur status, the privileged operation of photography as a pleasurable hobby, is also evident in his jealous retention of vast sequences of work now in several public collections. This study of cliffs north of Auckland was made by the wet collodion technique, in which a glass plate was coated with sticky chemicals shortly before exposure, and developed in a portable dark-room immediately afterwards. It is very likely to be the photograph titled *Wangaparooa* which hung near watercolours by J.C. Hoyte and Albin Martin in the 1873 exhibition of the Auckland Society of Artists, the second and final time Kinder ever exhibited his work in public.

W.T. Locke Travers, another important amateur photographer, holds the distinction of contributing the first account in New Zealand of landscape photography using the wet-plate technology. "Notes on the practice of out-door photography" was read before the Wellington Philosophical Society on 28 October 1871, and published the following year. It is a fascinating document of this heroic phase of photographic endeavour, and describes the two-wheeled dark-room which sometimes appears in his photographs. Travers was proud of the high standards he achieved, and unlike Kinder he regularly exhibited his photographs in local and foreign exhibitions. These included the international exhibitions at Sydney (1879) and Melbourne (1880), and London's Colonial and Indian Exhibition of 1886.

1 Dunn 1985.

TRAVERS: FOSTER 1966; MAIN 1972, 1985; SCHOLEFIELD 1940; TRAVERS 1870, 1872; WOODWARD 1987.

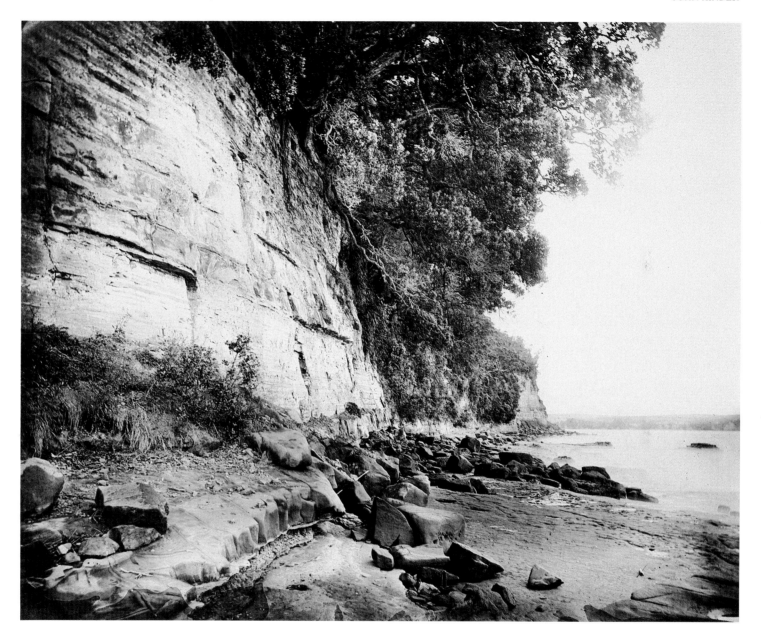

KINDER: BROWN 1970; BROWN & KEITH 1969; BROWNSON & DUNN 1985; DOCKING 1971; DUNN 1985; KEITH 1958, 1983; KNIGHT 1971, 1981; MAIN 1977; POUND 1983a; SCHOLEFIELD 1940.

W.M. HODGKINS  (1833-1898)
*Near Haywood's Point*  2 September 1876
watercolour, 161 x 287 mm
Alexander Turnbull Library, Wellington,
Field-Hodgkins bequest, 1977

Nicholas CHEVALIER  (1828-1902)
*Crossing the Teremakau*  1876
watercolour, 452 x 680 mm
National Art Gallery, Wellington,
bequest of Caroline Chevalier, 1918

By profession a lawyer, William Mathew Hodgkins was a gifted amateur watercolourist and leading propagandist for the arts in Dunedin, which was then New Zealand's most prosperous city.  He was one of the founders of the Otago Art Society in 1876, organised the establishment of Dunedin's first art gallery in 1884, and contributed letters and essays on art to the local newspapers.  In "A history of landscape art and its study in New Zealand", a lecture to the Otago Institute in November 1880, Hodgkins characterised New Zealand as a composite of "the special features of every country which is remarkable for its scenery."[1]  His fluent watercolour style, partly due to his early study of the works of J.M.W. Turner, was equal both to massive studio works and intimate studies made directly from nature.  This study of the play of light on a rock face is characteristic of the works in his personal collection now preserved in the Turnbull Library.

Nicholas Chevalier built up a vast collection of outdoor sketches while on wide-ranging painting trips in the South Island during the mid 1860s, work which was funded by the Provincial Councils of Otago and Canterbury. Chevalier left these sketches to the nation of New Zealand, and his widow later bequeathed other paintings which had remained in her own collection. Caroline Chevalier billed herself as "the first lady" to cross the Southern Alps, and her journal is an entertaining account of a transition from genteel Melbourne to some of the roughest country in Australasia. "We emerged at last as evening was fast coming on, then had to make the first crossing of the Teremakau. It looked nothing at all to do & most picturesque, but it was far from agreeable, huge mossy boulders & all more or less slimy, so that one had to be on the look-out, and make a dash at a given moment."[2]

1 Hodgkins 1880, in Entwisle 1984, p.160.
2 Chevalier MS, p.17.

HODGKINS:  COLLINS 1976, 1979;  DOCKING 1971;  ENTWISLE 1984;  HODGKINS 1880;  KING 1988, 1989;  O'KEEFFE 1940;  POUND 1983a;  SCHOLEFIELD 1940.

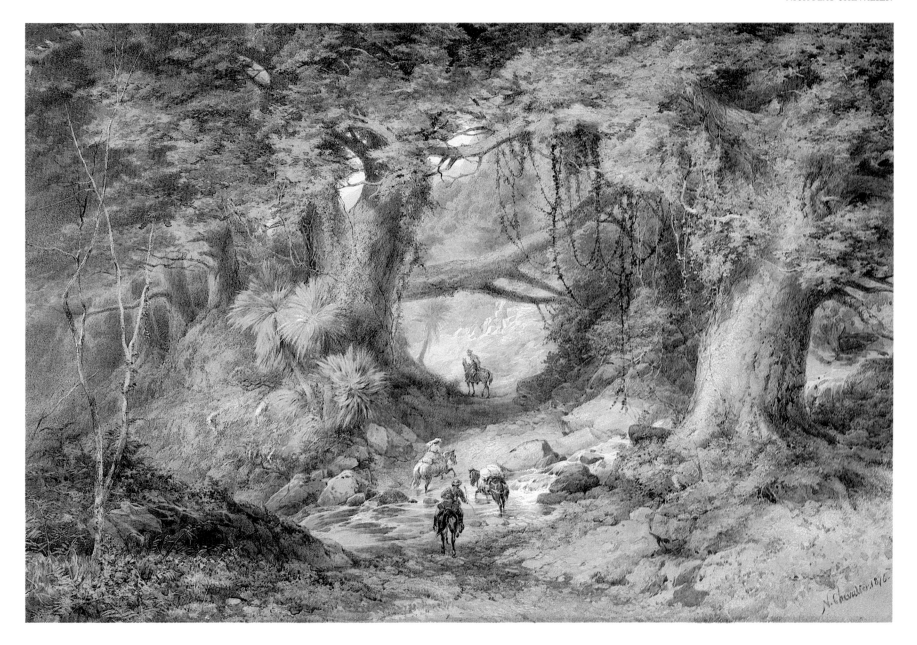

CHEVALIER: BELL 1987; CHEVALIER 1866; H. CURNOW 1981; DAY 1980, 1981, 1984; DOCKING 1971; MACLENNAN 1961; SCHOLEFIELD 1940.

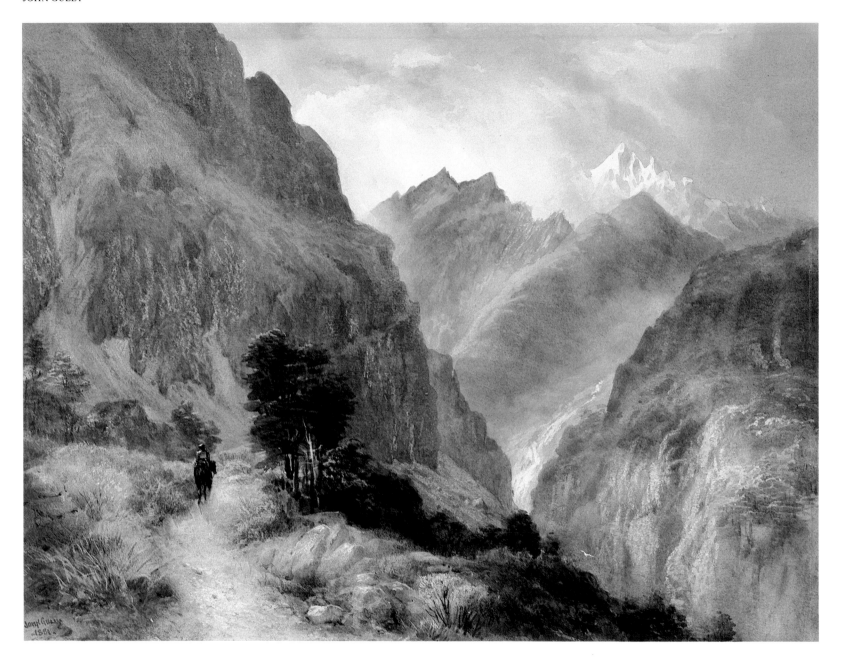

GULLY: DOCKING 1971; ENTWISLE 1984; ESPLIN 1966; GULLY 1984; LEE 1935a, 1935b; PAUL 1977-78; POUND 1983a; SCHOLEFIELD 1940.

Nelson artist John Gully specialised in watercolours of South Island views, frequently working on a very grand scale. The large number of works he produced, together with the relatively high prices he asked for them (up to £100), point to Gully's position as one of the most successful New Zealand artists of the nineteenth century. He was also one of the most widely known artists of the period, exhibiting in London, Vienna, Melbourne, Sydney, and throughout New Zealand.

The spectacular mountain scenery of the South Island attracted many Australian artists, of whom the most significant was Eugene von Guérard. Trained in Düsseldorf, von Guérard established himself during the 1850s and 1860s as Melbourne's pre-eminent landscape painter. In 1870 he became Master of the Painting School and Curator of the Victorian National Gallery. Over the next busy decade, von Guérard made only two summer sketching tours, to Tasmania in 1875, and to New Zealand in January 1876. Together with other eminent lovers of the picturesque, he left Melbourne in the steamship *Otago*, taking four and a half days to reach Milford Sound. The sublime beauty of this grandest of all the southern sounds was famous throughout Australasia, and probably visited more by Australians than by New Zealanders. Von Guérard then travelled on to Wakatipu, where he sketched the spectacular vista at the head of the lake.

Back in Melbourne, von Guérard spent much of the year working on the two grandest canvases of his career. They caused a sensation when shown in 1877 at the Victorian Academy of Arts, and over the following decade went on to become the most widely exhibited New Zealand paintings of the nineteenth century. They appeared at the Exposition Universelle de Paris in 1878, the Sydney International Exhibition in 1879, the Melbourne International Exhibition in 1880, and London's Colonial and Indian Exhibition in 1886.

(Overleaf)

Eugene von GUÉRARD (1811-1901)
*Milford Sound with Pembroke Peak and Bowen Falls on the West Coast of Middle Island, New Zealand* 1877-79
oil on canvas, 992 x 1760 mm
Art Gallery of New South Wales, Sydney

Eugene von GUÉRARD (1811-1901)
*Lake Wakatipu with Mount Earnslaw, Middle Island, New Zealand* 1877-79
oil on canvas, 991 x 1765 mm
Auckland City Art Gallery,
Mackelvie Trust Collection, 1971

John GULLY (1819-1888)
*In the Southern Alps* 1881
watercolour, 455 x 600 mm
National Art Gallery, Wellington,
presented by the New Zealand Academy of Fine Arts, 1936

VON GUÉRARD: BRUCE 1980; BRUCE, COMSTOCK & McDONALD 1982; BRUCE & COMSTOCK 1984; COLLINS 1979.

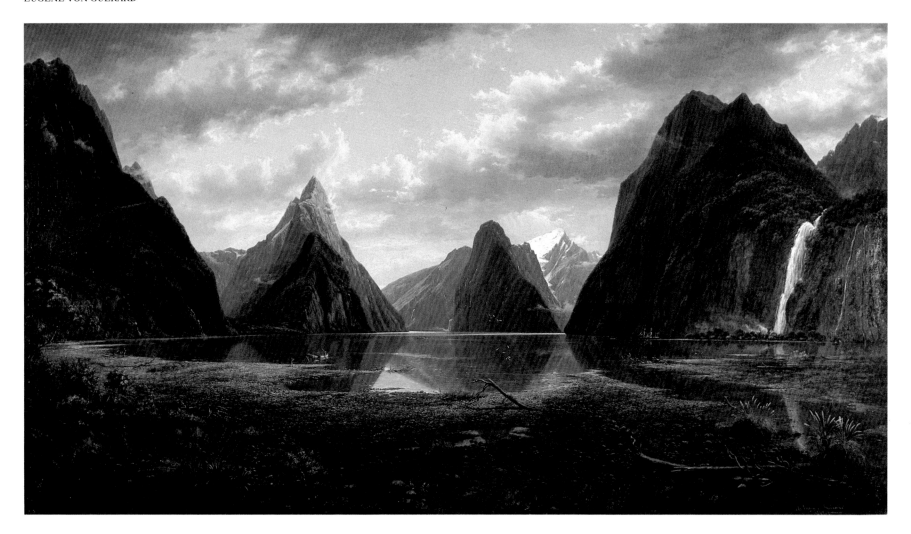

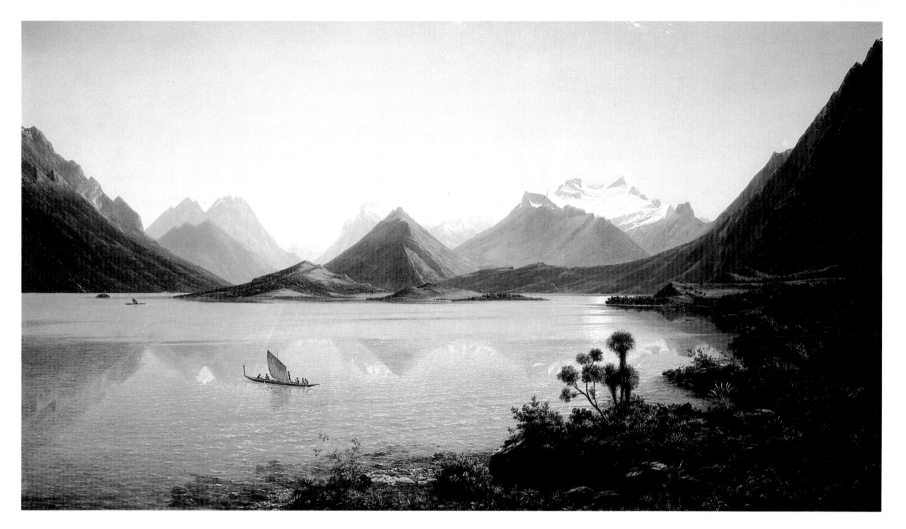

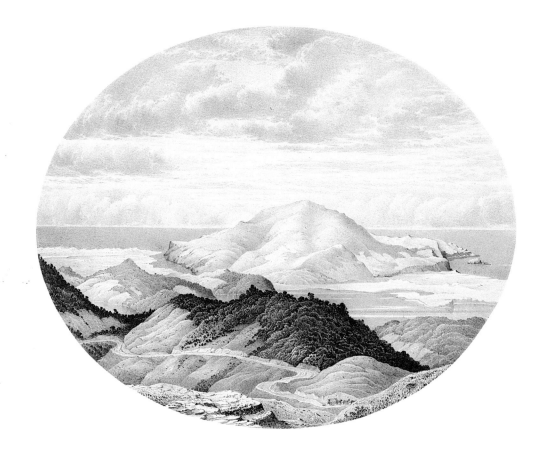

George O'BRIEN (1821-1888)
*View of Cape Saunders Peninsula* c.1876
pencil with opaque white, 235 x 290 mm
Auckland City Art Gallery, purchased 1982

George O'BRIEN (1821-1888)
*Otago Heads from Signal Hill* 1872
watercolour, 468 x 620 mm
Auckland City Art Gallery, purchased 1981

After a decade of periodic employment as a civil engineer and architectural draughtsman, in 1872 George O'Brien finally gained a secure position as Dunedin's Assistant Surveyor. *Otago Heads from Signal Hill*, along with its matching view from the opposite side of the harbour, is based on an earlier pair of views. This time, however, the scale is more ambitious, and in the foreground O'Brien pays tribute to his profession by portraying himself at work. An analogy is set up between the surveyor squinting through his theodolite, and the neatly parcelled landscape beyond. O'Brien loved operating within an oval format, rarely found in the work of other New Zealand watercolourists, fashioning views which seem to fit the shape perfectly, like smoothly convex cameos.

At the inaugural exhibition of the Otago Art Society in 1876, O'Brien exhibited an overwhelming total of 28 works. These included pencil drawings, of which one reviewer wrote that "seldom is so great an excellence attained in the use of the black-lead pencil."[1] Although obviously vying for a position within Dunedin's emerging art culture, O'Brien's magical realism ran counter to prevailing taste. Other reviewers were significantly more hostile, one denouncing the works as "exceedingly elaborate" and "all more or less disagreeable", while another dismissed O'Brien's meticulous handling by proclaiming "this accuracy is, however, quite destructive of artistic effect, but a few centuries hence the record will prove interesting."[2] Little more than a century later, O'Brien is acknowledged as one of the greatest of New Zealand's nineteenth-century artists.

1 quoted in Collins & Entwisle 1986, p.35.
2 quoted ibid., p.36.

O'BRIEN: BLACKLEY 1985; BURNS 1982; COLLINS 1976-77, 1979; COLLINS & ENTWISLE 1986; DOCKING 1971; KEITH 1983; O'KEEFFE 1940; POUND 1983a.

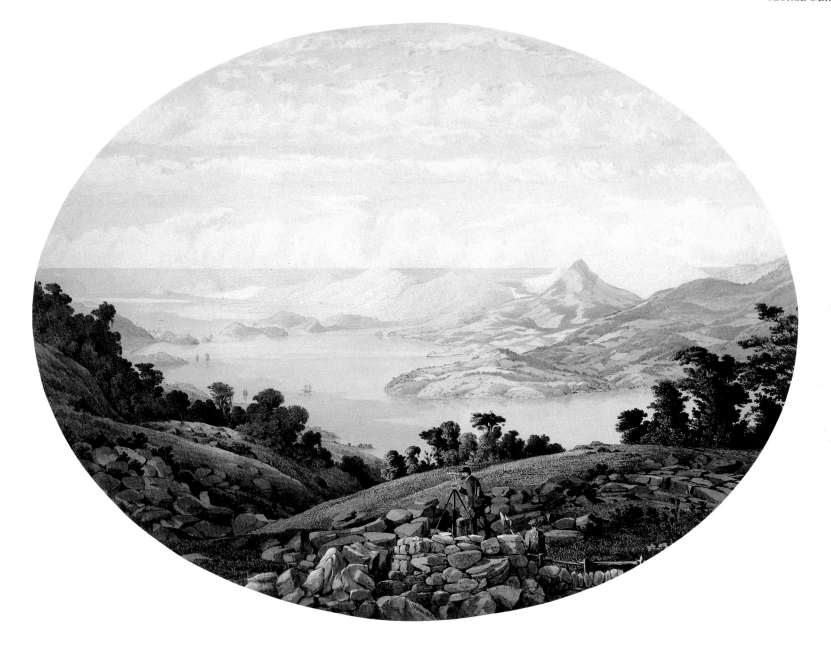

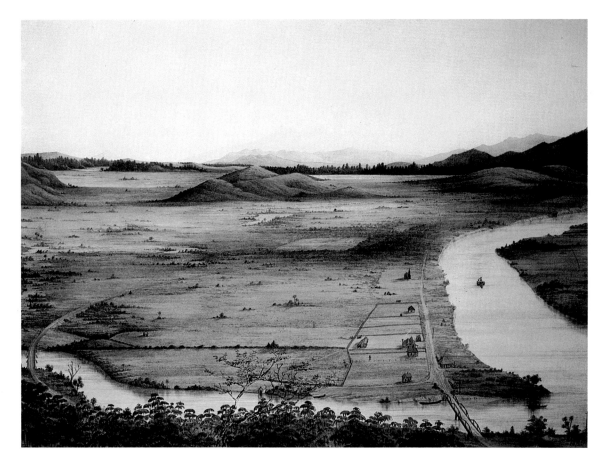

Alfred Sharpe's elaborate watercolours were executed during the leisure available from regular employment as a draughtsman, and probably for this reason his work met critical detraction remarkably similar to that received by George O'Brien. And just as O'Brien concentrated almost exclusively on Otago subjects, Sharpe's works are generally restricted to a geographically narrow range of landscapes easily accessible from Auckland. By 1876 the Waikato railway had reached Taupiri, skirting the hill and crossing the bridge on the left. Sharpe's vantage point, "Little Taupiri Hill", is the sacred burial place of the Tainui tribes, looking out across the lands which had been confiscated following the Waikato war of 1863-64. On a label originally fixed to the back of the painting, Sharpe explained his decision to paint a sunset view. "As a rule nothing is more dingy than the scenery of the Waikato district in broad daylight with its browns and grey-greens, but at sunset the landscape lights up with the most gorgeous colours: orange, yellow & dark violets and purples predominating."[1]

*Under the pohutukawa trees* is a portrait of an ancient denizen of Te Urutapu, a centuries-old grove of sacred pohutukawa in what is now the garden of the Mon Desir Hotel. When first shown in a Queen Street shop window, the painting attracted favourable notice. "The drawing of the tree is life-like, and the trunk, branches, and leaves are worked up with almost Pre-Raffaelite minuteness. The result, however, is good and the artist will be but poorly repaid for his time and trouble by receipt of the small sum demanded for this exquisite picture."[2] Priced at seven guineas, this was one of four large watercolours which Sharpe exhibited at the New South Wales Academy of Art's 1876 exhibition of works of colonial art.

1 for the full text of the label, see Pound 1985, p.96, and Brown 1988, p.86.
2 *New Zealand Herald*, 3 February 1876, p.2.

Alfred SHARPE   (1836-1908)
*View of Taupiri village & plain from the top of Little
Taupiri Hill. Sunset*  1876
watercolour, 512 x 702 mm
Auckland City Art Gallery,
presented by the Rev. Charles Palmer, 1951

Alfred SHARPE   (1836-1908)
*Under the pohutukawa trees at Lake Takapuna*
January 1876
watercolour, 448 x 620 mm
Auckland City Art Gallery,
presented by Rear-Admiral F. Burgess-Watson, 1935

SHARPE: BLACKLEY 1977, 1978; DOCKING 1971; KEITH 1983; KIRKER & YOUNG 1973; POUND 1983a; SHARPE 1880-82.

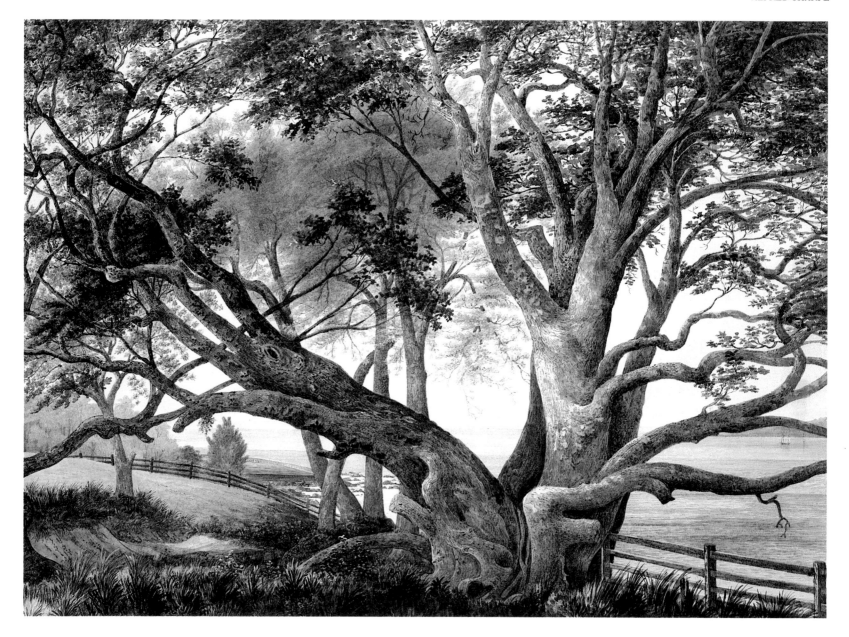

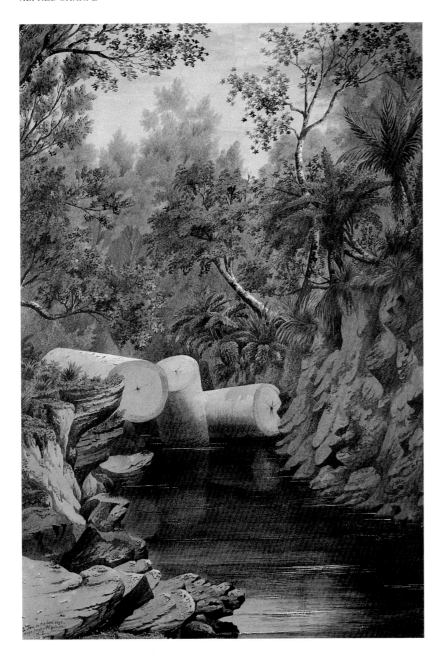

Alfred SHARPE   (1836-1908)
*A jam in the lava cleft, Hay's Creek, Papakura*  1878
watercolour, 635 x 432 mm
Auckland City Art Gallery,
presented by John Leech, 1936

Kennett WATKINS   (1847-1933)
*The home of the cormorants, Waitakere Ranges*  1886
gouache, 584 x 768 mm
Auckland City Art Gallery,
presented by the students of the artist, 1888

In contrast to J.C. Hoyte and other watercolourists who
transformed damaged landscapes into Arcadian visions,
Sharpe frequently noted the essential fragility of New
Zealand "nature."  At the centre of this composition are
three kauri logs, stranded during their passage from
high-country forest to the sawmill below.  Pale and
smooth, these packaged artefacts resemble the remnants
of a Doric colonnade, mysteriously at rest in the bush.
In his important series of essays on the art of watercol-
our painting, Sharpe instructed that a scrupulous
realism ("go reverently to Nature and pourtray her as
she is") would result in paintings "worthy to be placed
amongst works which will in the future be characterised
as the 'In Memoriam' of what will then be our historical
forests."[1]

Kennett Watkins, the teacher at Auckland's first school
of art, was also instrumental in founding the New
Zealand Art Students' Association in 1883.  One aim was
"to promote a patriotic view of New Zealand art by every
means in their power."  In contrast with the "exotic" art
promoted by the main art society, Watkins argued for an
art "of our soil, an indigenous product."[2]

1 Sharpe 1882.
2 Watkins 1883a & 1883b.

WATKINS: SCHOLEFIELD 1940; WATKINS 1883a, 1883b.

Charles BLOMFIELD (1848-1926)
*Castle Hill, Coromandel. Sunrise, from the Mercury Bay track* 1888
oil on canvas, 505 x 765 mm
Auckland City Art Gallery,
presented by Albert Devore, 1889

Charles BLOMFIELD (1848-1926)
*Top of Tarawera* 1887
oil on canvas, 460 x 760 mm
Private collection, Auckland

A self-taught artist, Charles Blomfield established his reputation (and a small fortune) by producing views of the Pink and White Terraces at Rotomahana. In a letter of 1883, he quotes approvingly from an American writer on the "patriotic" duties of the landscape artist. "Never before has there been a nobler opportunity afforded the artist to aid in the growth of his native land, and to feel that, while ministering to his own love of the sublime and beautiful, he was at the same time a teacher and co-worker with the pioneer, the man of science, and the soldier, who cleared, surveyed and held this mighty continent and brought it under the mild sway of civilisation."[1]

*Castle Hill* depicts a famous Coromandel landmark, transfigured by the early morning light. Unlike Sharpe, whose 1884 watercolour of the same location shows timber workers in the vicinity of giant kauri trees, Blomfield characteristically diverts attention away from explicit signs of damage caused to the landscape by industries such as forestry and mining.

In October 1886, four months after the eruption of Tarawera, Blomfield returned to make sketches of the devastated site of the terraces. From these, he was able to present "before and after" pairs of views in his "Gallery of New Zealand Art" in Auckland's Victoria Arcade, which lay on the tourist route between wharf and hotels. *Top of Tarawera* shows a group of intrepid tourists inspecting the awesome crater, while below is the steaming pit which marks the site of the vanished terraces. Blomfield's market nostalgically demanded replicas of the earlier terrace paintings, but it is with unique works such as *Top of Tarawera* that he made his most significant contribution.

1 Blomfield 1883.

BLOMFIELD: BLACKLEY 1987; BLOMFIELD 1883; DOCKING 1971; POUND 1983a; WILLIAMS 1979.

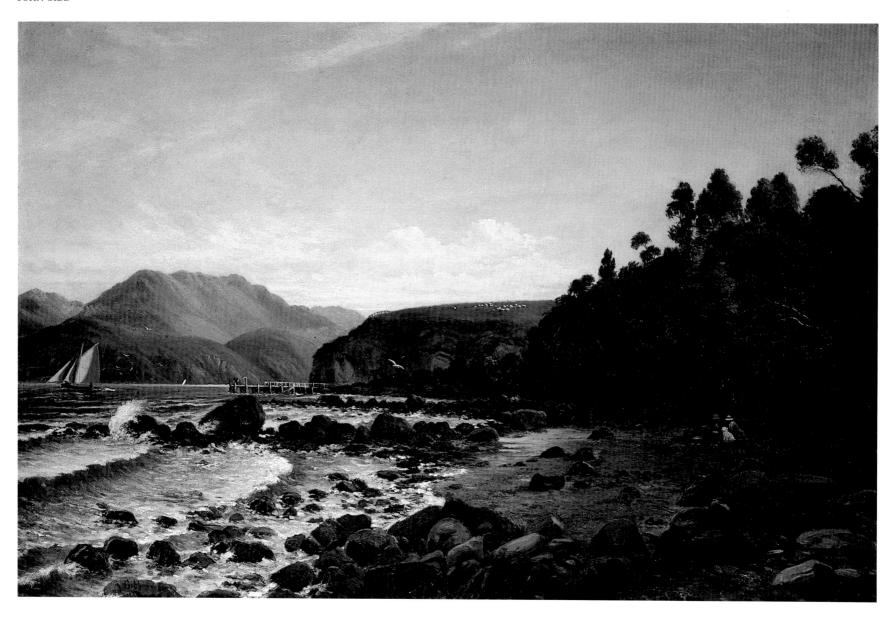

GIBB: DOCKING 1971; GIBB 1900; SCHOLEFIELD 1940.

John GIBB   (1831-1909)
*Low tide, Governor's Bay*  1883
oil on canvas, 505 x 762 mm
Auckland City Art Gallery, purchased 1964

Wilhelm GEISLER   (c.1828-1897)
*Knight's swamp on the road to Motueka*  c.1884
oil on cardboard, 182 x 272 mm
Fletcher Collection, Auckland

Scottish-trained painter John Gibb arrived in Christ-church in 1876, where he set up as a professional artist and teacher. Together with Blomfield and Gully, Gibb was among the most prolific of the country's nineteenth-century artists, regularly exhibiting throughout New Zealand, and as far afield as Sydney, Melbourne, London and St Louis. This is a view of the popular picnic spot at the head of Lyttelton Harbour, so called because it was where Governor George Grey waited to welcome the ships carrying the first Canterbury settlers in December 1850.

Other artists continued to operate as itinerants, making only brief appearances in New Zealand. One such shadowy figure is Wilhelm Geisler, who was in Nelson by 1881 and whose recorded landscape work is mainly of South Island subjects. These include Dusky Sound, Greymouth, Motueka, Nelson and Timaru. Although "Professor Geisler" exhibited with the Wellington Association of Fine Arts in 1883 and 1884, his naive style made little impact on local connoisseurs. Taking his paintings with him, Geisler disappeared.[1]

1 on a collection of Geisler's work in Germany, see "Small mystery of the Geisler paintings", *Auckland Weekly News*, 20 July 1966, p.17.

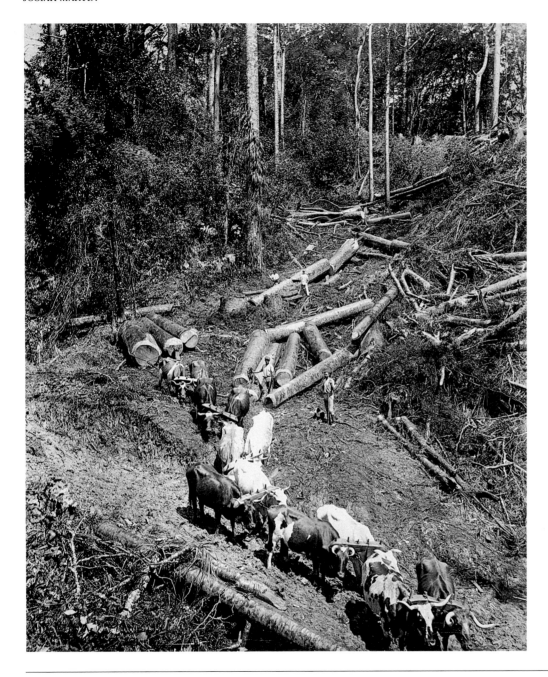

Josiah MARTIN  (1843-1916)
*Hauling kauri logs*  c.1890
albumen silver photograph, 300 x 247 mm
National Museum, Wellington

Josiah Martin's first photographs employed the wet-plate technique, but while visiting London in 1879 he made a study of the new dry-plate technology at the Royal College of Chemistry. This allowed for greater working freedom, including much shorter exposures which permitted photography of transitory phenomena such as geysers in eruption, and the possibility of generating huge stocks of images. From a six-week expedition to Rotorua and Rotomahana in 1883, Martin returned to Auckland with no fewer than 300 views. *Hauling kauri logs* was made on one of his summer expeditions in the North, and the choice of subject relates to his awareness that New Zealand's "virgin beauty" could not resist "the so-called 'march of civilisation'."[1]

1 Martin 1885.

MARTIN: KNIGHT 1971; MAIN 1977; TURNER 1970.

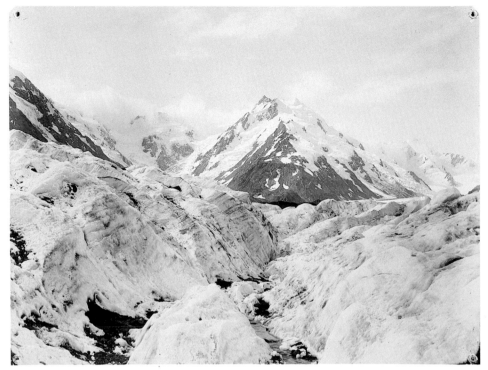

George MOODIE   (active c.1890-1916)
*Mount de la Bêche from Tasman Glacier*  1893
gelatin silver photograph, 212 x 287 mm
National Museum, Wellington

George MOODIE   (active c.1890-1916)
*Mangapukata, Wanganui River*  c.1890
albumen silver photograph, 332 x 425 mm
National Museum, Wellington

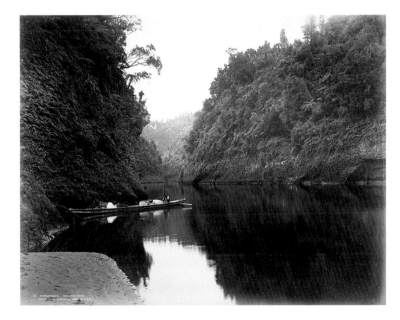

George Moodie and portrait photographer Thomas B. Muir were Muir and Moodie, continuing the successful Dunedin photographic firm of Burton Brothers. George Moodie was an outstanding photographer who extended the heroic landscape researches of his celebrated predecessor, Alfred Burton. His view from the Tasman Glacier is a technical and artistic triumph, regardless of the athletic considerations of carrying camera, tripod and glass dry-plates. *Mangapukata* also represents a formidable achievement, using massive glass plates over 12 x 16 inches in size. Muir and Moodie's business was significantly based on the Burton repertoire, and Moodie is clearly interested in extending the range of 6 x 8-inch views on the Wanganui which Alfred Burton made during his famous trip in 1885.

MOODIE: KNIGHT 1971; MAIN 1972, 1977.

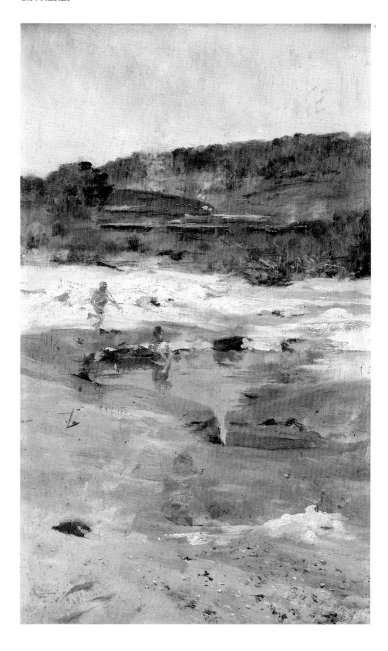

G.P. NERLI   (1860-1926)
*Near the Postmaster's Bath, Rotorua*  1896-97
oil on board, 305 x 190 mm
National Art Gallery, Wellington,
presented by the New Zealand Academy of Fine Arts,
1936

Petrus van der VELDEN   (1837-1913)
*A waterfall in the Otira Gorge*  1891
oil on canvas, 1135 x 1940 mm
Dunedin Public Art Gallery

Girolamo Pieri Nerli studied at the Accademia delle Belle Arti in Florence, and came under the sway of the Tuscan impressionist painters known as *I Macchiaioli*, (the blotchers). He first visited Dunedin in 1889 for the New Zealand and South Seas Exhibition, and returned there in 1893, setting up for several years as a professional painter and teacher. In the summer of 1896-97, en route from Dunedin to Auckland, Nerli visited the newly established spa-town of Rotorua. Painted on the spot in a limited palette, *Near the Postmaster's Bath* brilliantly evokes the sultry, vaporous landscape of Rotorua.

Dutch painter Petrus van der Velden arrived in Christchurch in 1890, and the following summer he made his first sketching trip to Otira. *A waterfall in the Otira Gorge* is typical of van der Velden's penumbral aesthetic, which favoured stormy twilight scenes above all others. Leonard H. Booth, a pupil of van der Velden's, recounts a wonderful tale of the artist's working methods. "When I was last at Otira, a resident of the place who remembered van der Velden told me that the Dutchman was evidently quite mad. Evidently? Yes; because at all those times when thunder rolled, and wind howled, and rain poured, van der Velden would go into the Gorge, whereas at all those times when the sun shone from a cloudless sky, he would lie with his back to the grass near the hotel and sleep."[1]

1 Booth 1930, p.11.

NERLI: DOCKING 1971; DUNN 1985-86, 1988-89; ENTWISLE 1984; ENTWISLE, DUNN & COLLINS 1988; MACKLE 1984; O'KEEFFE 1940.

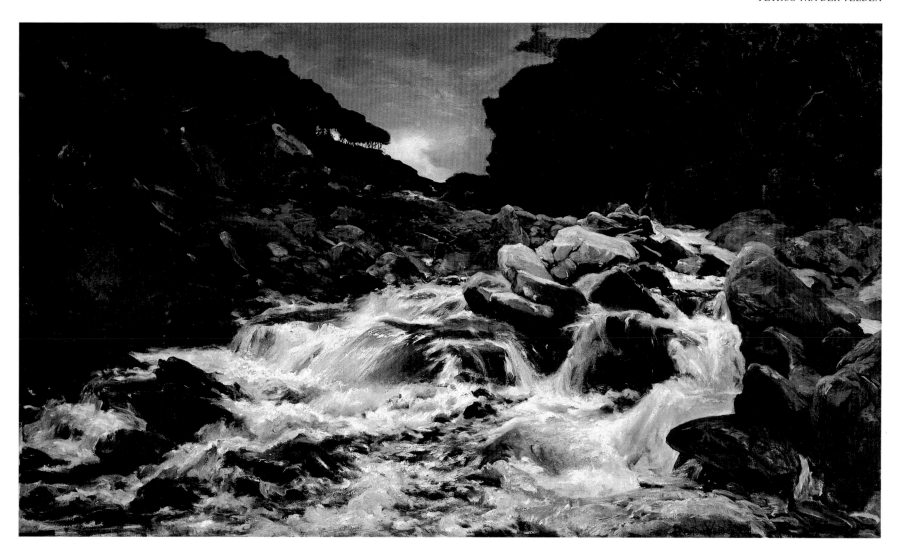

VAN DER VELDEN: BOOTH 1930; BROWN & KEITH 1969, DOCKING 1971; NICOLL 1928; POUND 1983a; SCHOLEFIELD 1940; TOMORY 1959; WILSON 1976, 1977, 1979.

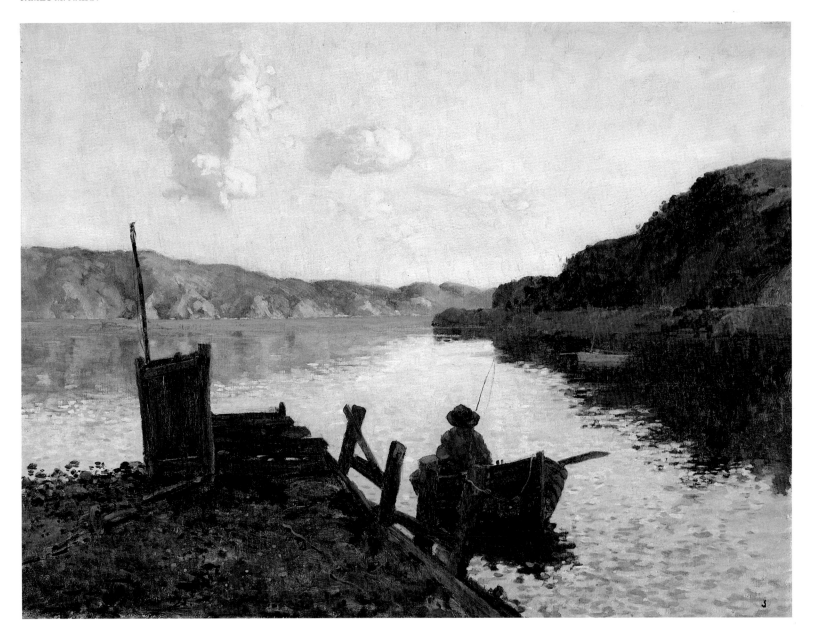

NAIRN: BILLCLIFFE 1985; BROWN & KEITH 1969; DOCKING 1971; DUNN 1977, 1985-86; EDWARDS & MAGURK 1940; ESPLIN 1966; JOHNSTON 1942; McCAHON 1964; MACKLE 1984; NAIRN 1892, 1896; POUND 1983a, 1983b; SCHOLEFIELD 1940; TRIPE 1928.

James M. NAIRN   (1859-1904)
*Evans Bay, Wellington*  1893
oil on canvas, 565 x 740 mm
National Art Gallery, Wellington,
bequest of Miss S. Leetham, 1939

James M. NAIRN   (1859-1904)
*Wharf at Kaikoura with S.S. Wakatu*  1903
oil on cardboard, 260 x 337 mm
Auckland City Art Gallery, purchased 1961

James M. NAIRN   (1859-1904)
*Sunset*  1903
oil on cardboard, 250 x 293 mm
Auckland City Art Gallery, purchased 1970

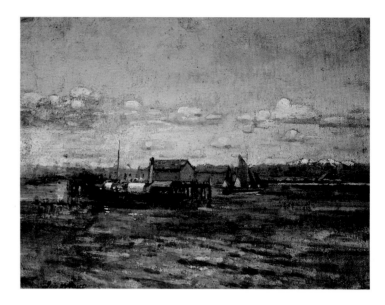

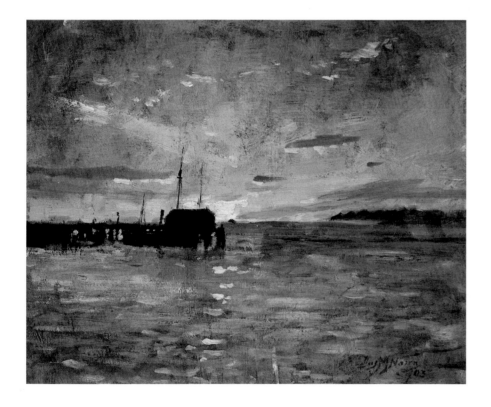

Scottish painter James McLachlan Nairn emigrated to New Zealand for
reasons of health, arriving in 1890. His early association with the
Glasgow School, a group of Scottish impressionists, meant that he was
committed to painting *en plein air*. As his friend and pupil M.E.R. Tripe
explained, his paintings were executed "on the spot - not faked up in the
studio from sketches." Tripe went on to report that "when away on a
sketching tour Nairn used to say that one should do three sketches each
day - one before breakfast, another at 12, and a third after three o'clock
in the afternoon. It was an exciting moment when he came back from
one of his trips with a bundle of unmounted sketches, some of which he
sold for 30/-!"[1]

Wellington critics labelled Nairn's work as "bilious" and "chromatic
lunacy", but Nairn was resolute. "I shall always make a point of trying to
outrage the taste of the ordinary public, as I do not want them to like my
work."[2] In 1892, depressed by the amateur management of the New
Zealand Academy of Fine Arts, Nairn and a group of enthusiasts founded
the rival Wellington Art Club. At weekends and holidays these friends
joined Nairn at Pumpkin Cottage in Silverstream for sketching, "a few
bottles of lunch", bohemian cookery, and perhaps even Jimmy Nairn on
the bagpipes.

1 Tripe 1928, pp.105, 106.
2 quoted in Edwards & Magurk 1940, p.222.

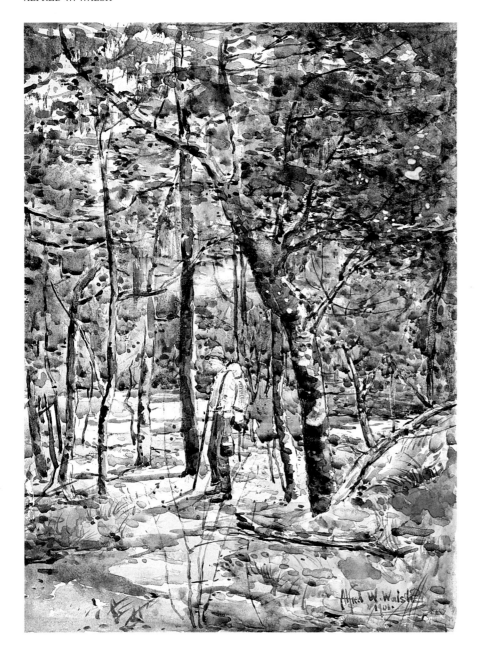

Alfred W. WALSH   (1859-1919)
*In the bush*  1901
watercolour, 400 x 295 mm
Auckland City Art Gallery, purchased 1957

Edward FRISTRÖM   (1864-1950)
*Motutapu*  c.1908
oil on canvasboard, 234 x 280 mm
Auckland City Art Gallery, purchased 1969

Alfred Walsh's first art lessons in Dunedin were from David Con Hutton and George O'Brien, but his mature watercolour style clearly owes more to the influence of W.M. Hodgkins. Working outside, drawing directly in wet blobs of paint, Walsh effectively ignored any distinction between preliminary sketch and studio painting. Most of his best watercolours were produced *en plein air*, usually on weekend or holiday trips away from teaching duties at the Canterbury College School of Art. John Cam Duncan later described Walsh's working method: "over the paper, with its chaotic mass of flowing colour - he was a wet worker - his brushes, guided by instinct, genius - I knew not what - darted here and there designing, taking out, putting in all those telling blobs of colour which went toward the making of one of his exquisite landscapes."[1]

Substitute "canvas" for "paper", and this passage could also serve to describe Edward Friström at work. A Swedish-born artist who worked in Australia before arriving in Auckland in 1903, Friström was a master of the outdoor oil sketch. These were usually executed on small home-made canvasboards, but sometimes directly on commercial cardboard. He taught at the Elam School of Art from 1911 to 1915, and his lively technique and vibrant palette influenced younger artists such as Archibald F. Nicoll and Robert Johnson.

1 Duncan 1929, p.170.

WALSH: DOCKING 1971; DUNCAN 1929; DUNN 1985-86; MACLENNAN 1966; MACKLE 1984; SCHOLEFIELD 1940; WAUCHOP 1940.

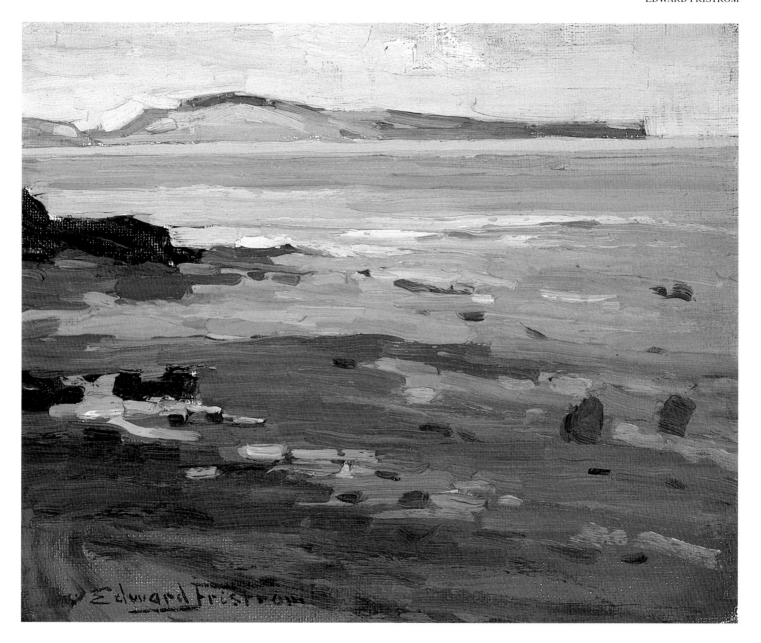

FRISTRÖM: DOCKING 1971; McCAHON 1964; MACKLE 1984; POUND 1983a; WILSON 1981a, 1981b.

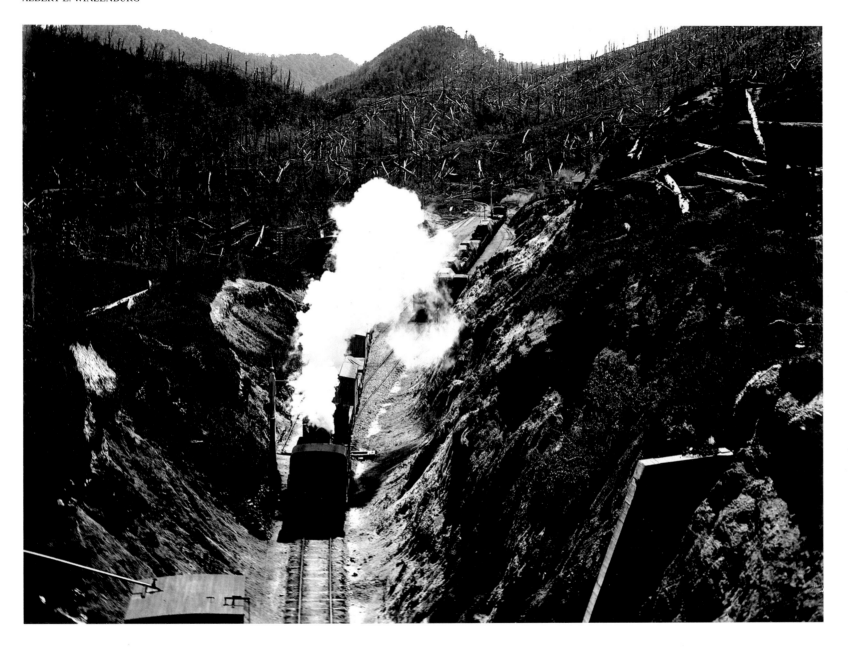

Albert E. WINZENBURG   (active 1900-1920)
*Rimutaka incline*  c.1900
gelatin silver photograph, 213 x 292 mm
Alexander Turnbull Library, Wellington

Trevor LLOYD   (1865-1937)
*The death of a moa*  c.1925
watercolour and gouache, 520 x 385 mm
Auckland City Art Gallery,
bequest of Connie Lloyd, 1983

Trevor Lloyd's artistic signature was the kiwi, and his
satirical cartoons produced for the *New Zealand Herald*
and *Auckland Weekly News* between 1904 and 1937 were
largely responsible for securing this bird as an accept-
able national emblem. Born in North Auckland, Lloyd's
only formal art training consisted of some painting
lessons from L. J. Steele. He never travelled, preferring
to roam Auckland's rugged west coast, sketching and
fossicking for relics from the Maori past. He took up
etching around 1918, and eventually produced a huge
body of prints based on his bush drawings. Around 1925
he began incorporating Maori fairy figures, the legen-
dary patupaiarehe, in prints with titles such as *Once
upon a time*. Made for the enjoyment of his family, this
watercolour is one of Lloyd's most ambitious works. The
giant moa has achieved extinction, observed by an
anthology of native birds and patupaiarehe.

Albert Winzenburg's photograph is the necessary
corrective to Lloyd's nostalgic fantasia. Commissioned
by the Railways Department to record the triumphal
progress of the railway over the Rimutaka Range,
Winzenburg's photograph is a strikingly vivid depiction
of the ecological havoc wreaked by colonial appropria-
tion of a primeval landscape.

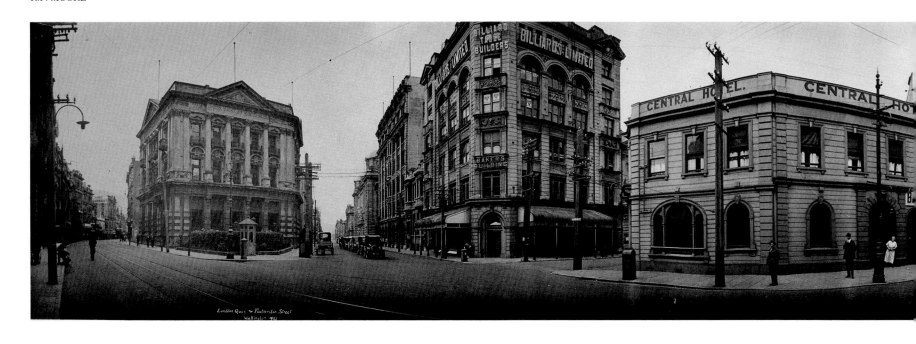

R. P. MOORE   (active 1923-1928)
*Lambton Quay and Featherston Street, Wellington*   1923
gelatin silver photograph, 225 x 980 mm
Alexander Turnbull Library, Wellington

Frederick SYKES   (1867-1945)
*D.I.C. looking north: End of World War I*   1919
oil on board, 615 x 429 mm
Hocken Library, Dunedin,
presented by Miss V.E. Sykes

The notion of landscape today encompasses all kinds of environment, from city street to virgin forest, but it is unlikely that these two urban scenes could have been considered as "landscape art" by a contemporary audience. In the 1930s, the Bledisloe Landscape Medal was awarded to encourage the painting of New Zealand landscape, "landscape being defined as natural landscape of an uncultivated nature."[1] In the late 1950s, the Kelliher Art Prize continued this mission to encourage "pure" landscape, although its initial brief ("the natural beauties of our country") was later widened to include "panoramic views of cities and towns."[2]

Panoramic photographs, up to a metre wide and mounted in heavy oak frames, enjoyed an enormous vogue earlier this century. While nineteenth-century photographers such as John Kinder and Alfred Burton had concocted panoramic views by shifting the camera

MOORE: KNIGHT 1971.

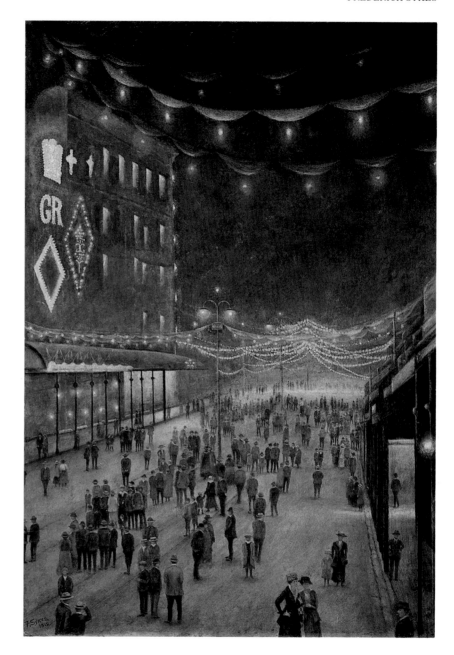

and later pasting the photographs side by side, R.P. Moore used a special panoramic camera to produce a seamless wide-angle view which was ideal for urban scenes.

An enigmatic amateur known only by a handful of paintings and drawings in the Hocken Library, Frederick Sykes appears never to have exhibited his work. *D.I.C. looking north* combines a weird perspective with very precise description of Dunedin's peace celebrations. Impressed by the way that festive electric illumination transformed the city's appearance at night, Sykes has left us a charmingly idiosyncratic picture which has no real parallel in the art of his Dunedin contemporaries.

1 "Art notes." *Art in New Zealand*, 10, 3, (39), March 1938, p.175.
2 King 1979, p.109.

SYKES: BROWN 1972.

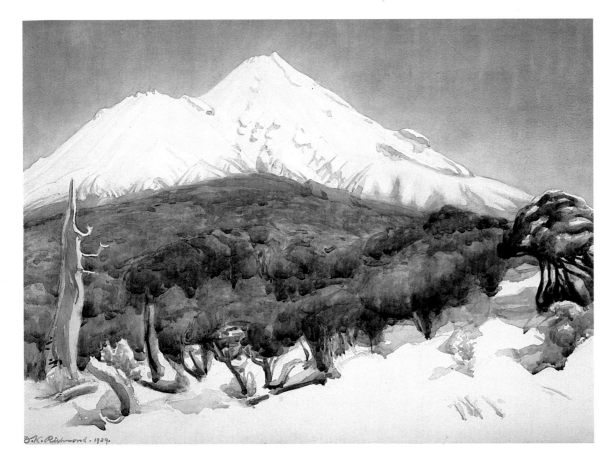

Dorothy Kate Richmond was the daughter of J.C. Richmond, and inherited her father's fluency in water-colour painting. She studied in France and England, and returned definitively in 1903 to a painting and teaching career in Wellington. She was a leading member of the New Zealand Academy of Fine Arts and a prime mover in the establishment of the National Art Gallery. A proficient painter in oils, she excelled in watercolour, producing works in which her friend Dr Carbery diagnosed "a transparency, a soprano quality, a spontaneous effect of impromptu utterance."[1]

Born in Auckland, Robert Johnson studied under Archibald F. Nicoll and Edward Friström. He served as an artilleryman in Europe during World War I, where he made watercolours in the trenches and ruined cities. Back in New Zealand, he transformed his sketches of war-torn France and Belgium into oil paintings on a grand scale. His true talent, however, lay in painting directly from nature, camping on the spot ready for the light to be just right. Johnson moved to Sydney in 1920, and with his vibrant outdoor work established a reputation as one of Australia's leading landscape painters.

A river valley depicted from a high vantage-point was a favourite subject for painters of the 1930s, and it was seized as a virtual archetype of New Zealand landscape by a later generation of populist painters of whom Peter McIntyre is the best known. Appropriately, Robert Johnson was invited back to New Zealand in 1957 to judge the second Kelliher Art Prize, awarded for "realistic and traditional" landscape painting.

D.K. RICHMOND   (1861-1935)
*Mount Egmont*  1929
watercolour, 574 x 751 mm
National Art Gallery, Wellington,
presented by the nieces and nephews of the artist, 1937

Robert JOHNSON   (1890-1964)
*The Dress Circle, Kawhatau Valley*   1928
oil on canvas mounted on board, 380 x 455
Auckland City Art Gallery, purchased 1928

1 Carbery 1935, p.9.

RICHMOND, D.K.: CARBERY 1935; DOCKING 1971; HOCKEN LIBRARY 1966; KIRKER 1986; MACKLE 1984; SCHOLEFIELD 1940.

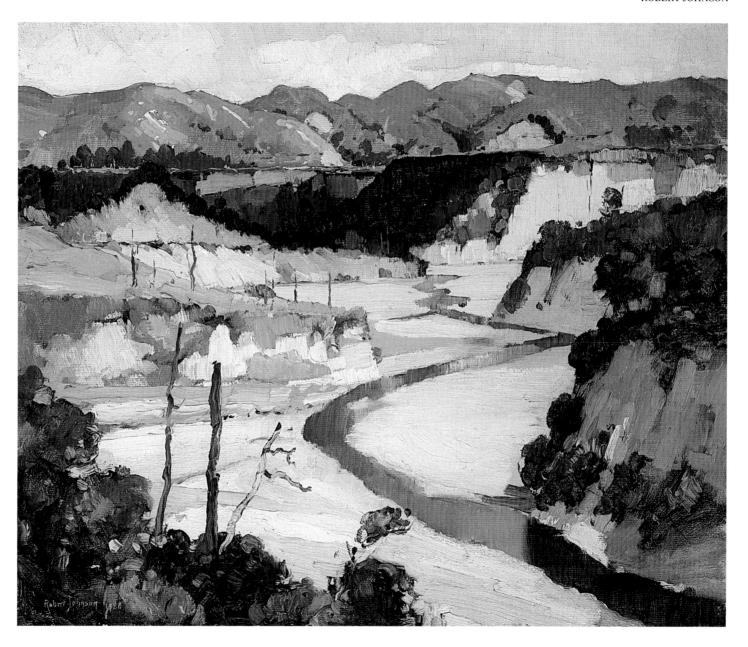

JOHNSON: DOCKING 1971; DUNN 1985-86; GOUDIE & RUHEN 1953; McCULLOCH 1968; TAYLOR 1934; WATERHOUSE 1934.

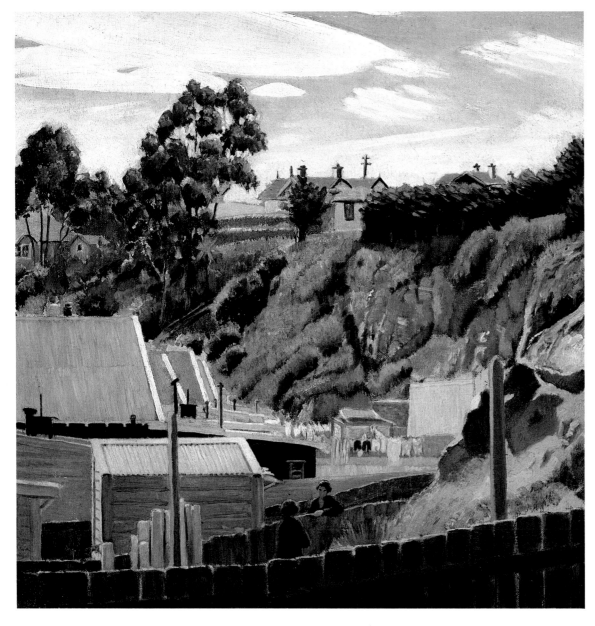

W.H. ALLEN  (1894-1988)
*Backyards, Musselburgh, Dunedin*  1930
oil on board, 370 x 370 mm
National Art Gallery, Wellington
The Ellen Eames Collection, purchased 1983

Robert N. FIELD  (1899-1987)
*Landscape, Taieri Mouth*  1930
oil on canvas mounted on board, 260 x 332 mm
National Art Gallery, Wellington

William Henry Allen and Robert Nettleton Field were both graduates of London's Royal College of Art. In 1925, Allen drew Field's attention to an advertisement for two art teachers required by Dunedin School of Art. This plan to revitalise New Zealand art education by recruiting staff with English qualifications was the brainchild of W.S. La Trobe, Superintendent of Technical Instruction. On arrival in Dunedin, Field and Allen were shocked to discover that the School of Art consisted of a small department of King Edward VII Technical College, with only seven adolescent students enrolled in the full-time course.

Field published a number of essays on art and art education, but the most important lesson he provided was the example of his own work. M.T. Woollaston, who studied under Field in 1932, later wrote: "His pictures, brilliant and heady, were painted with jewel-like, full-sized brush strokes, or with rainbow-like spots and scales of pure paint shimmering on unpainted backgrounds of wood or canvas. Here was wild excitement after what, it now became plain, had been my long drought of earnest mediocrity."[1]

Allen's style was a more sober affair, as evidenced by this superb painting made in the artist's backyard shortly before he and his family returned to England. As Francis Shurrock commented in an essay of 1940: "There are no tricks of brushwork, colour or design, and the fundamental value of forms is always fully realised. There is no stumbling; all is cool, steady, strong and colourful."[2]

1 Woollaston 1962, p.31.
2 Shurrock 1940, p.7.

ALLEN: ALLEN 1929; DUNN 1970; SHURROCK 1940.

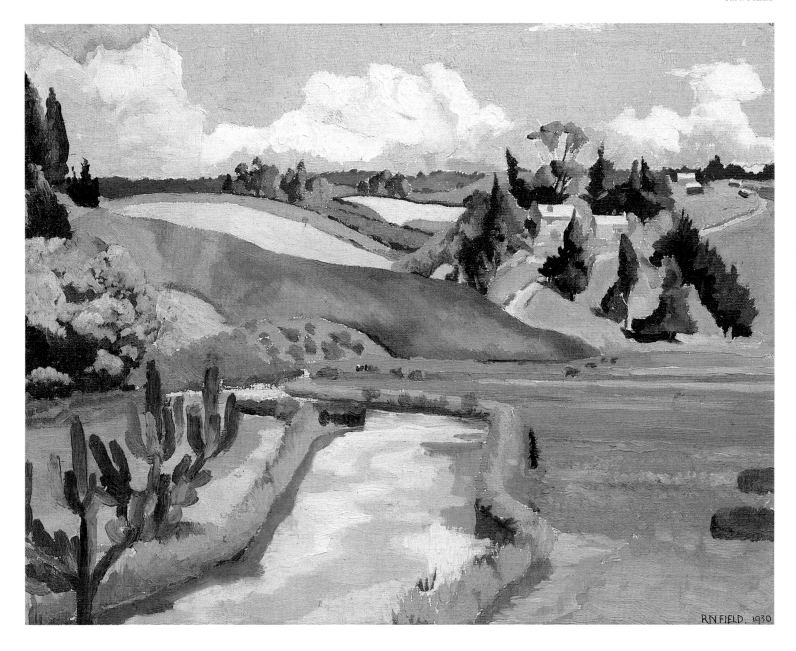

FIELD: ALLEN 1938; DOCKING 1971; DUNN 1979b; FIELD 1940, 1941; FRASER 1981; MACKLE 1984; PETERSEN 1987, 1989; WILSON 1980.

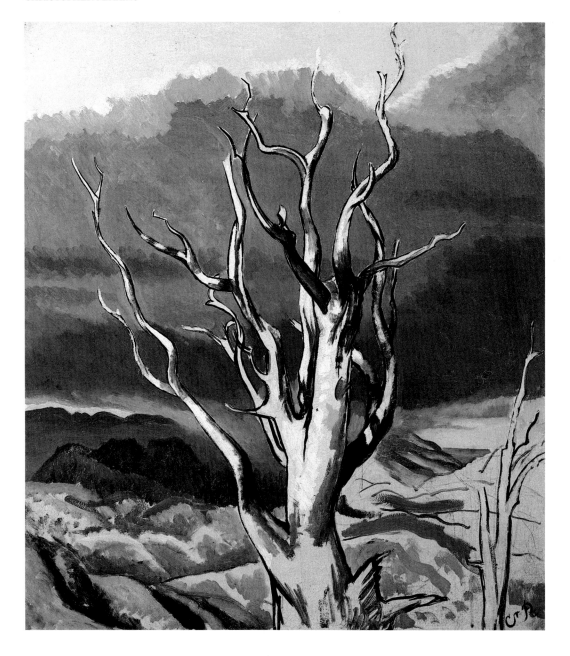

Christopher PERKINS   (1891-1968)
*Frozen flames*  1931
oil on canvas, 690 x 610 mm
Auckland City Art Gallery,
presented by the Friends of Auckland City Art Gallery,
1962

Christopher PERKINS   (1891-1968)
*Taranaki*  1931
oil on canvas, 505 x 912 mm
Auckland City Art Gallery, purchased 1968

Another La Trobe recruit, Christopher Perkins had studied at London's Slade School in the heady days before World War I, when Roger Fry was introducing French post-impressionism to English audiences. The Perkins family arrived in Wellington in 1929, and the outspoken painter quickly became a controversial member of the capital's art scene. His alienation from the insipid traditionalism he encountered may well have spurred him to produce, in five short years, some of the most powerful work of his career.

*Frozen flames* presents the skeleton of a tree, drawn with energetic brushstrokes, looking across a barren landscape towards a threatening pall of smoke. Reminiscent of the war work of Perkins's Slade School contemporary Paul Nash, *Frozen flames* is both a modernist exercise in pictorial structure, and an original contribution to the vocabulary of regionalist imagery in New Zealand.

Perkins visited Taranaki while on holiday from his job at the Technical College, and regretted that he could not emulate the Japanese printmaker Hokusai's celebrated views of Fujiyama by honouring Taranaki with such a series. But with just one picture, of the classic mountain towering over the angular forms of a dairy factory, Perkins created one of the icons of New Zealand art.

PERKINS: BROWN & KEITH 1969; DOCKING 1971; DUNN 1979a; GARRETT 1986; KEITH 1976; LAWTON 1975; PERKINS 1929, 1933, 1934, 1935; ROBERTSON 1931.

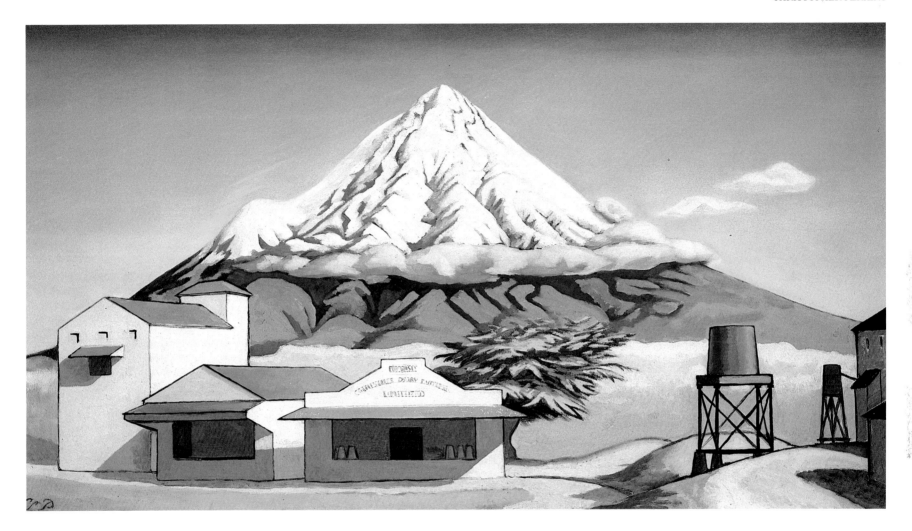

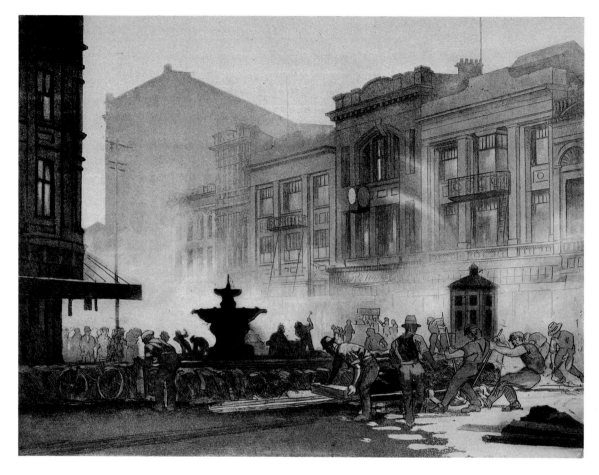

James FITZGERALD   (1869-1945)
*Repairing the road*  c.1932
colour aquatint, 225 x 300 mm
Hocken Library, Dunedin

Roland HIPKINS   (1894-1951)
*Renaissance*  1932
oil on canvas, 794 x 920 mm
Hawke's Bay Museum, Napier,
presented by the de Beer family, 1951

When the Hawke's Bay earthquake struck on 3 February 1931, a workman was putting the finishing touches to the spire of the brand-new Presbyterian church of St Paul's. Only hours later, the church was left gutted by the fire which swept through the ravaged city. The reconstruction of Napier began almost immediately, and some of the first exquisite art-deco shop frontages are depicted in the upper part of Roland Hipkins's *Renaissance*. Framed by the ruins of St Paul's, a new city rises phoenix-like from the ashes of the old. In the foreground stands a symbolic ponga, new fronds unfurling from the resilient trunk.

Recruited as an art teacher under the La Trobe scheme, Hipkins settled in Napier in 1922. In 1929 he and his wife, the painter Jenny Campbell, moved to Wellington where Hipkins joined Christopher Perkins at the Technical College. Like Perkins, Hipkins was a lively commentator on the arts, and was particularly interested in art education for children. And like Perkins, he was obsessed by the question of "national consciousness" and the emergence in art of "distinctive qualities recognisable as New Zealand in character."[1] For Hipkins, the "spirit" of New Zealand always possessed qualities both national and regional: "the expression of the spirit of a country must have national significance, at the same time preserving such individuality as will give the work some artistic interest as a human document."[2]

James Fitzgerald was an important Christchurch artist whose work is largely confined to etching. Technically very accomplished, a print like *Repairing the road* is especially interesting as a depiction of relief work undertaken for local authorities by gangs of unemployed workers during the Depression of the 1930s. Pay was extremely meagre, and the general discontent over the relief system erupted in the Auckland, Wellington and Dunedin riots of 1932.

1 Hipkins 1934, p.61.
2 ibid., p.62.

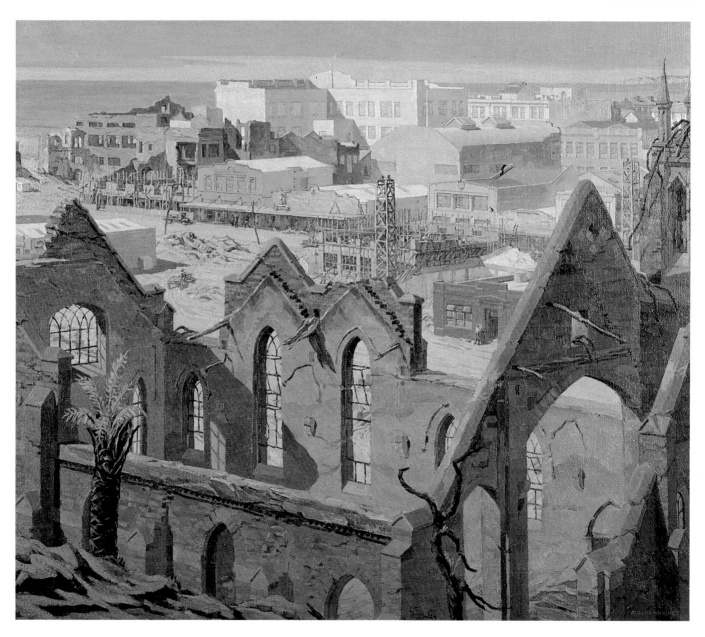

HIPKINS: DOCKING 1971; HIPKINS 1938, 1948; WAUCHOP 1937.

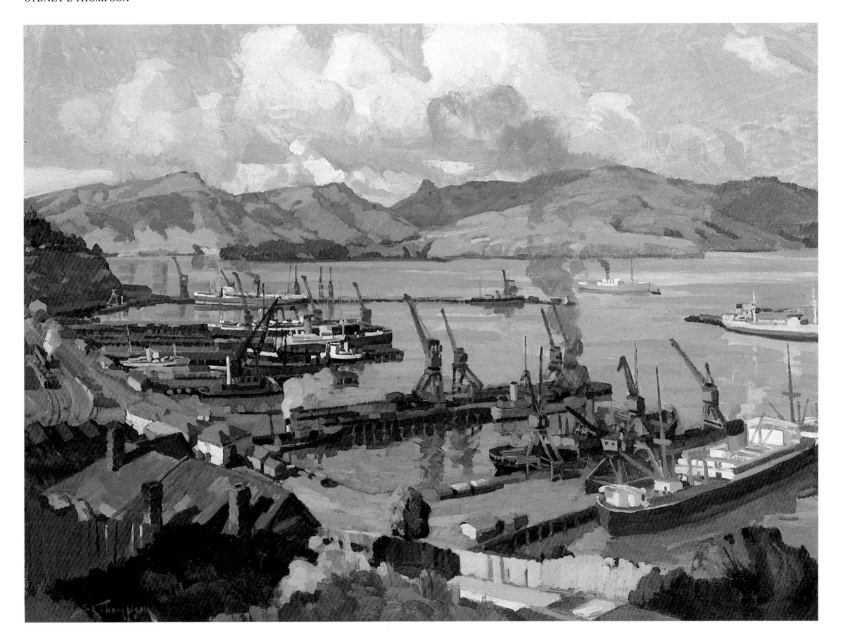

THOMPSON: DOCKING 1971; MACKLE 1984; MUIR 1976; SHELLEY 1936; THOMPSON 1939, 1943.

Sydney L. THOMPSON    (1877-1973)
*Lyttelton from the Bridle Path*  1937
oil on canvas, 950 x 1280 mm
Robert McDougall Art Gallery, Christchurch,
presented by the Lyttelton Harbour Board, 1938

M.T. WOOLLASTON    (born 1910)
*Wellington*  1937
oil on paper mounted on cardboard, 432 x 482 mm
Auckland City Art Gallery, purchased 1960

M.T. WOOLLASTON    (born 1910)
*Mapua*  c.1934
oil on canvas mounted on board, 270 x 355 mm
Auckland City Art Gallery,
presented by Mr & Mrs R.N. Field, 1982

Sydney Lough Thompson was born on the further
reaches of the Canterbury Plains, and later claimed that
he had never seen an oil painting until, as a teenager
visiting Christchurch, he first came across the work of
Petrus van der Velden.  Thompson took lessons from van
der Velden for three years before leaving for further
study in London and Paris.  Apart from a period
teaching at Canterbury College from 1904 to 1911, and a
triumphant return in the mid-1930s, most of his career
was spent as an expatriate painter based in the pictur-
esque Breton fishing port of Concarneau.

Mountford Tosswill Woollaston belongs to a later
generation of artists who chose to stay and develop their
artistic potential in New Zealand, instead of training
abroad.  Under the influence of R.N. Field, Woollaston
discovered an intuitive, gestural style which he has
continued to exploit in a career now spanning almost
sixty years.  In 1937 he discussed his recent painting
*Wellington*: "That picture was a piece of almost sponta-
neous painting, and is not so much a likeness of
Wellington as a symbol of my personal reaction to it.  I
must say I don't admire the Wellington domestic
architecture, and as I looked over the scene I felt that I
must express the actual chaos of Wellington's buildings
by an almost abstract symbol of chaos."[1]

1 Woollaston 1937, p.8.

WOOLLASTON:  BARNETT 1987;  BIERINGA 1970, 1973;  BROWN & KEITH 1969;  DOCKING 1970;  IRELAND 1974;  ISLANDS 1974;  O'REILLY 1948;  PORSOLT 1963;  SUMMERS 1967;  WOOLLASTON 1937, 1961, 1962, 1980, 1982.

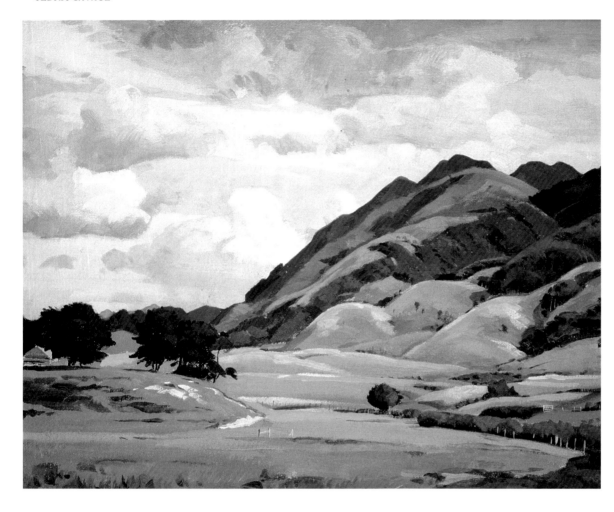

Archibald Frank Nicoll was born in rural Canterbury, and studied under Sydney L. Thompson. He taught painting for three years at Elam School of Art in Auckland, before travelling to study in London, Edinburgh and Glasgow. After service in World War I, he became Director of Canterbury College School of Art until 1928, when he retired to devote himself entirely to painting. He was a highly competent portraitist, always inundated with commissions from eminent citizens, but it was his landscape output which allowed the true expression of his creativity.

*Peninsula, winter* represented Nicoll in the Centennial Exhibition of 1940, and is a brilliant example of this artist's exploration of the tonal possibilities of the Akaroa Hills in their various seasonal disguises. In 1947, Nicoll wrote: "As to methods and aims, my work I suppose discloses my varying methods and the partial realization of my aims. My philosophy of painting hardly amounts to a philosophy at all but is something much simpler than that. To set down selections of shapes and colours of objects seen in nature has for most of my life been a normal, natural thing to do. One hopes always to be seeing (and feeling) more and better, and then getting something of it fixed in a drawing or painting with what skill and cunning can be brought to the job."[1]

Born in Christchurch, Cedric Savage studied at Canterbury College but spent the 1930s in Fiji and Australia. Back in New Zealand during World War II, he established himself as one of Wellington's most popular painters. A commentator mentioned in 1945 that Savage was one of the first whose works sold at each Academy exhibition, explaining that he "captures the golden sunlight of New Zealand in its most halcyon moods with devices that can only be called brilliant."[2] Savage won the Kelliher Art Prize in 1961, but his best work was produced on the painting excursions he made out of Wellington in the early 1940s.

1 Nicoll 1947, p.41.
2 *Year Book of the Arts in New Zealand*, 1, 1945, p.89.

Cedric SAVAGE   (1901-1969)
*Porirua pastures* c.1942
oil on canvas mounted on cardboard, 379 x 482 mm
Auckland City Art Gallery, purchased 1985

Archibald F. NICOLL   (1886-1953)
*Peninsula, winter* c.1932
oil on canvas, 642 x 824 mm
National Art Gallery, Wellington,
presented by the New Zealand Academy of Fine Arts,
1936

SAVAGE: MACKLE 1984; WADMAN 1948.

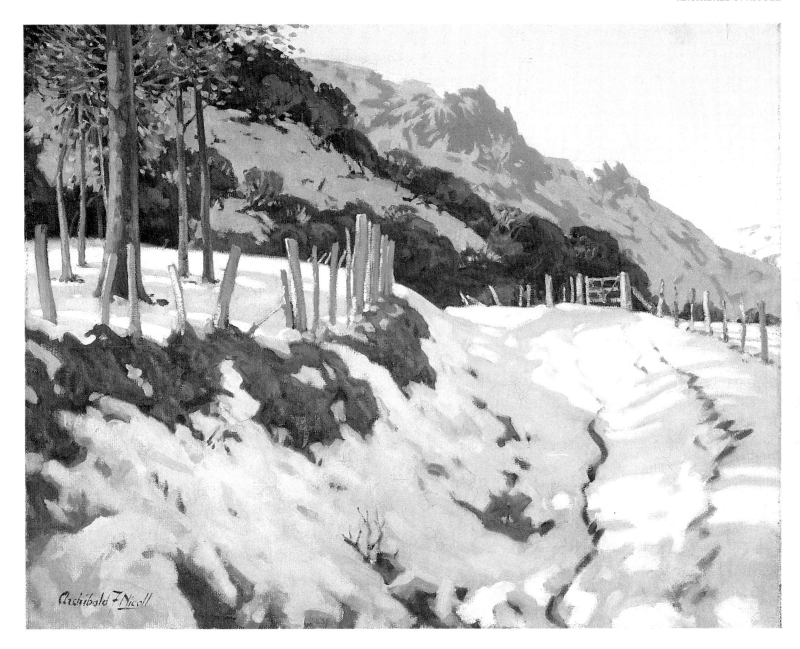

NICOLL: ANONYMOUS 1932; ESPLIN 1966; MACKLE 1984; NICOLL 1947; SHELLEY 1932.

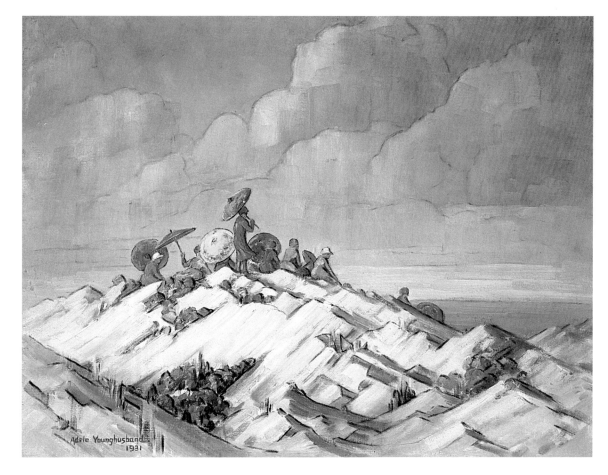

Adele YOUNGHUSBAND   (1890-1965)
*Sand dunes* 1931
oil on canvas, 473 x 624 mm
Auckland City Art Gallery, purchased 1980

Frances I. HUNT  (1890-1981)
*P.W.D. tents, pumice country, Taupo* c.1935
oil on board, 310 x 405 mm
Auckland City Art Gallery, purchased 1951

Adele Younghusband worked as a professional photographer, but her real interest lay in painting. This is a good example of the landscape style she perfected in the 1930s, before study under George Bell in Melbourne led her towards figure compositions and a self-conscious abstract surrealism. Christopher Perkins praised New Zealand's "marvellous light", and despite subsequent controversy over just how particular this light may be, its existence provides the very basis of the painter's art. *Sand dunes* is as much a study of the raking afternoon sunlight, as of the fashionably attired women relaxing at the beach.

Frances Hunt's first art lessons were at Frank Wright's academy in Victoria Arcade, and she became a working member of the Auckland Society of Arts in 1924. Eight years later, she enrolled as a student at Elam School of Art, entering the orbit of painting instructor John Weeks. In the words of her friend, E.H. McCormick: "[Weeks] was teacher, master, friend, the guide who gave her confidence in herself and eased her way in the transition from tentative amateur to assured professional."[1]

This painting was made on one of her many excursions in areas close to the family farm at Te Kuiti, and may well have been done in the company of Weeks. The canvas-roofed huts are part of an unemployed workers' camp erected by the Public Works Department. In exchange for back-breaking work, far from home and family, workers received "sustenance" well below an adequate living. With great painterly verve, Hunt has memorialised one of the bleak gulags of the Great Depression.

1 McCormick 1981-82, p.40.

YOUNGHUSBAND: HIPWELL 1941.

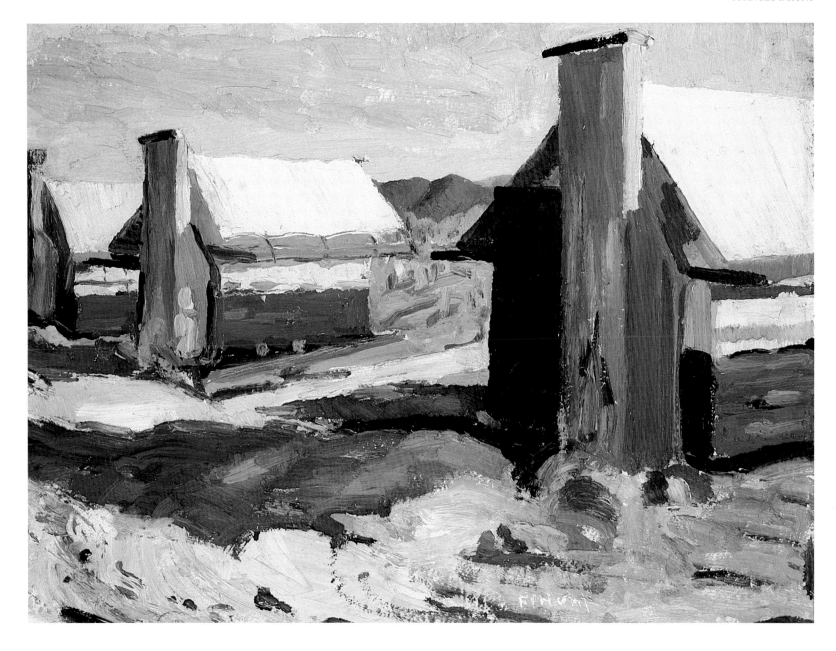

HUNT: McCORMICK 1981-82.

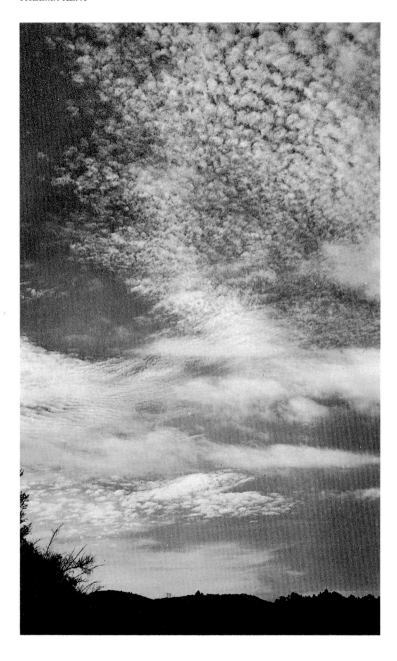

Thelma KENT  (1899-1946)
*Clouds* c.1939
gelatin silver photograph, 295 x 180 mm
Alexander Turnbull Library, Wellington

Nugent WELCH  (1881-1970)
*The coming storm* 1930
oil on canvas, 710 x 915 mm
Sarjeant Gallery, Wanganui,
commissioned with funds from the McCarthy Trust

Writing in 1917, E.A.S. Killick characterised
Wellington's as a particularly intractable landscape:
"Landscape painters in the Wellington district suffer
under some disabilities from the enclosed nature of their
surroundings and the lack of places to which to go.
There are only two roads running out of Wellington and
these for many miles lie between steep, bare ridges,
there being little or no landscape of the ordinary
pastoral nature."[1]  Welch's work in both watercolour and
oil painting celebrates the vertiginous hills and mobile
skies of landscapes near Wellington, in seemingly
endless variations on a theme.

A staunch member of the Christchurch Photographic
Society, Thelma Kent was a freelance pictorial journalist
whose work was published in magazines such as the
*Auckland Weekly News*.  "Sooner or later you will see a
car beside some lonely road, with a view nearby and a
tent efficiently pitched, workmanlike camping gear
around and, if you do not actually see her waving as you
pass, you may guess that Thelma Kent and a friend are
away out somewhere, looking for pictures, trying this
effect and that effect ..."[2]  Kent exhibited widely
overseas, from Lucknow to Luxembourg, and in essays,
lectures and radio broadcasts she tirelessly promoted the
interests of photography.

1 Killick 1917, p.88.
2 "A woman and her camera", *New Zealand Listener*, 25 August 1939, p.41.

KENT: KNIGHT 1971; McCRACKEN & SULLIVAN 1986.

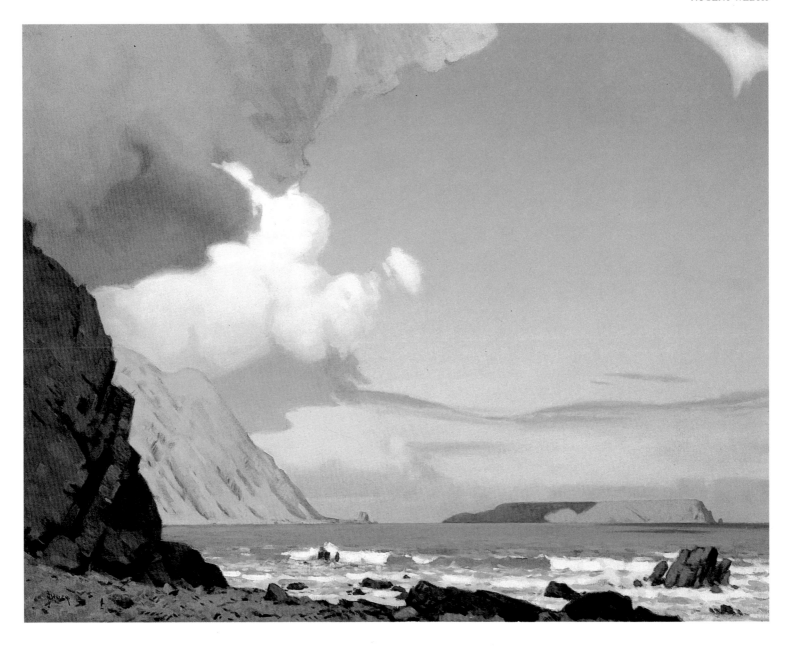

WELCH: HALL 1933; MACKLE 1984; MILLIGAN 1943.

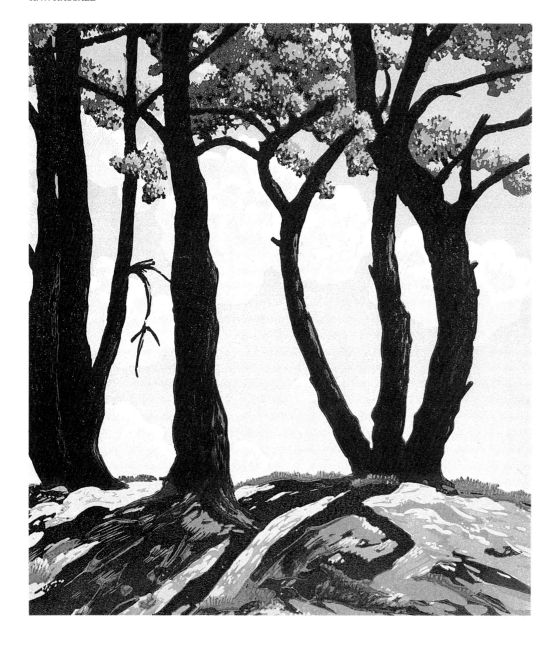

K.W. HASSALL   (1901-1970)
*Pine silhouette*  c.1945
colour linocut, 253 x 225 mm
Auckland City Art Gallery, purchased 1977

Connie LLOYD   (1895-1982)
*The twisted tree*  1935
aquatint, 149 x 171 mm
Auckland City Art Gallery, purchased 1935

George CHANCE   (1885 -1963)
*Tree study near Taihape*  c.1932
gelatin silver photograph, 260 x 210 mm
Auckland City Art Gallery, purchased 1987

Printmaking enjoyed a renaissance in New Zealand during the 1930s and 1940s, and R.N. Field and Adele Younghusband are examples of painters who also produced prints.  By contrast, Kenneth Hassall was a committed printmaker who sometimes also painted in oils.  The colour linocut technique, like the classic Japanese woodcut, demanded the production of a separate block for each colour, and the need for careful registration during printing.

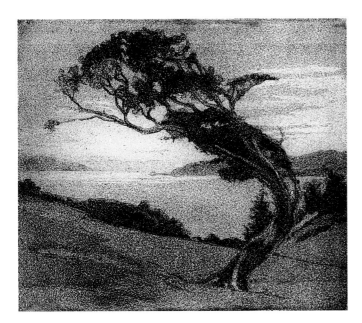

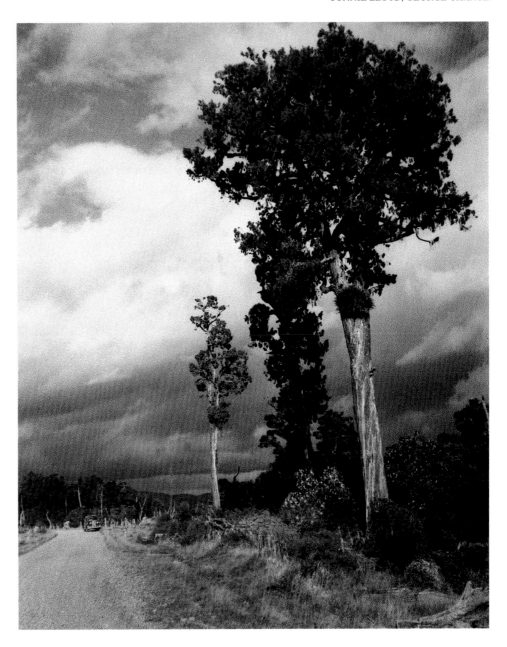

Connie Lloyd learned the art of etching around 1918 from A.J.C. Fisher, the principal at Elam School of Art. Like her father Trevor Lloyd, Connie Lloyd found her subjects in the landscape near Auckland. But whereas Trevor explored the linear properties inherent in traditional etching, Connie favoured the expressive potential of drypoint, and especially the granular soft-focus of aquatint.

George Chance arrived in New Zealand in 1909, bringing with him a knowledge of the pictorialist tendencies within recent British "art" photography. Manipulation of the negative, the use of multiple negatives, and the soft-focus effect achieved by printing through a textured screen, were all devices intended to "elevate" his work from the realm of documentary photography to that of art. Chance's vision of a rural paradise was immensely popular, and later in his career he claimed to have sold over 30,000 photographs. Titles frequently varied over time, and this print is also known as *Relics of the forest* and *Where once a mighty forest stood*.

CHANCE: ALCOCK 1988; KNIGHT 1971; TELFORD & MAIN 1985.

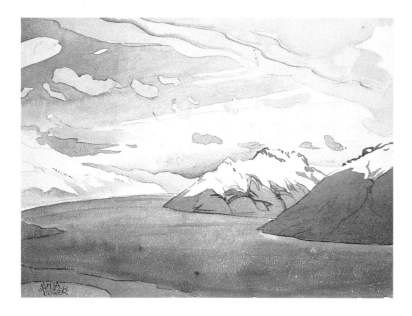

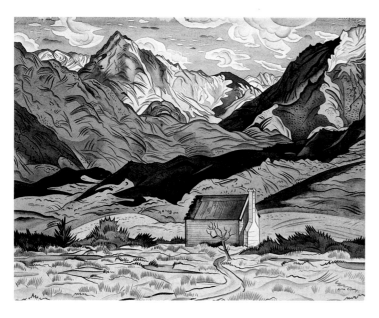

Olivia SPENCER BOWER   (1905-1982)
*Nor'west light, Wakatipu*  c.1938
watercolour, 282 x 399 mm
Auckland City Art Gallery, purchased 1979

Rita ANGUS   (1908-1970)
*Mountains, Cass*  1936
watercolour, 368 x 496 mm
Robert McDougall Art Gallery, Christchurch,
presented by Robert Erwin in memory of Lawrence
Baigent, 1985

T.A. McCORMACK   (1883-1973)
*Orongorongo mountains*  c.1957
watercolour, 565 x 762 mm
National Art Gallery, Wellington,
presented by the New Zealand Academy of Fine Arts,
1958

John HOLMWOOD   (1910-1987)
*Wellington wharf*  1944
watercolour, 318 x 394 mm
Auckland City Art Gallery, purchased 1980

SPENCER BOWER: ADAMS 1983; ANONYMOUS 1969; DOCKING 1971; ISLANDS 1974; KIRKER 1986; MITCHELL 1977.

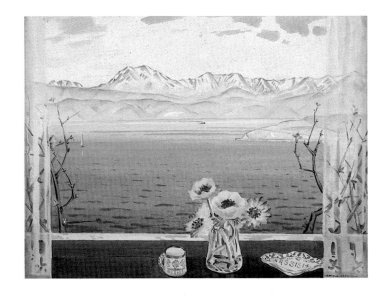

One of the most adventurous proponents of watercolour painting in the 1930s was Olivia Spencer Bower, whose contact with the work T.A. McCormack exhibited with The Group in Christchurch confirmed her own movement towards a spontaneous, calligraphic technique. In *Nor'west light, Wakatipu*, the icy blue of the lake below the scudding golden clouds is communicated with an almost visionary intensity. An equivalent intensity is achieved by Rita Angus in *Mountains, Cass*, where in place of Spencer Bower's breadth of handling we find a meticulous craftsmanship in which Angus subjects the clouds and mountains to an insistent linear patterning.

John Holmwood demonstrates something of Angus's control in this study of the visual drama of Wellington's wharves, while T.A. McCormack provides a late example of the spontaneous handling which so impressed Spencer Bower. Thomas Arthur McCormack was almost entirely self-taught, and worked exclusively in watercolour. His works are remarkable for their freshness and simplicity, and were described by Roland Hipkins as "less the direct record of nature than an attempt to evoke a mood similar to that expressed in a poem." [1] Another commentator in 1945 remarked that "McCormack, like an old, dry sherry, is an acquired taste and to be relished as such. His colour is sophisticated, and its range is restricted by a kind of patrician reticence ..." [2]

1 Hipkins 1936, p.192.
2 *Year Book of the Arts in New Zealand*, 1, 1945, p.80.

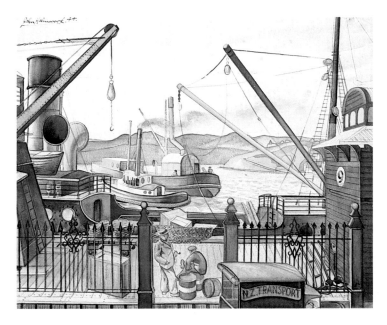

McCORMACK: BEAGLEHOLE 1936; COUNIHAN 1939; DOCKING 1971; HALL 1959; HIPKINS 1936; KIRKER 1983; MACKLE 1984; McCORMACK 1947.

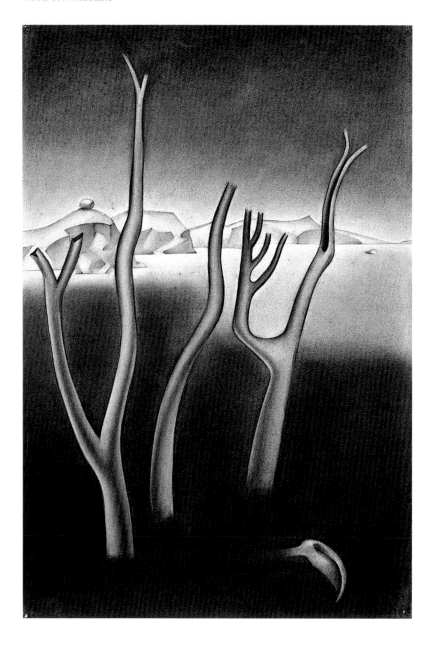

Gordon WALTERS   (born 1919)
*Waikanae landscape*  1944
black conté, 560 x 381 mm
Private collection,
on loan to Auckland City Art Gallery

Eric LEE-JOHNSON   (born 1908)
*Out of the swing of the sea*  1945
watercolour and ink, 533 x 625 mm
Auckland City Art Gallery, purchased 1945

The origin of Gordon Walters's surrealist drawings of the
1940s lay in photographs he made of dead trees, stones
and sand patterns at Waikanae, using a camera lent by
his friend Theo Schoon.  The resulting conté drawings
employ a mysterious, deep space reminiscent of the
French surrealist Yves Tanguy, whose work Walters
knew through reproduction.  The smooth tree in
*Waikanae landscape* is not rooted in the land, but floats
before an empty, distant coastline, while the sense of
menace is enhanced by a skeletal beak-like form in the
foreground.

After training at Elam School of Art, Eric Lee-Johnson
spent the 1930s working as a commercial artist in
London.  On his return in 1938, driving through the
King Country landscape he knew as a child, he felt that
the mute skeletons of the forest had turned out to greet
him.  Their gaunt forms became a favourite subject for
his watercolours, which revel in the sheer untidiness of
the "tamed" landscape.  *Out of the swing of the sea* is a
masterpiece of introspective surrealism, based on
nature's own collections of extraordinary objects.  As
Hipkins wrote in 1948:  "With a restless imaginative
research into problems of representation, rocks,
seaweed, driftwood and dead trees are transmuted into a
fantasy of forms that assume a curious strangeness.  He
is concerned with the unseen, and invites the spectator
to share his own subjective adventures." [1]

1 Hipkins 1948, p.109.

WALTERS:  BELL 1983;  DOCKING 1971;  DUNN 1978, 1979, 1980, 1983a, 1984;  HIPKINS 1948;  HUTCHINGS 1984;  ISLANDS 1974; ROSS & SIMMONS 1989.

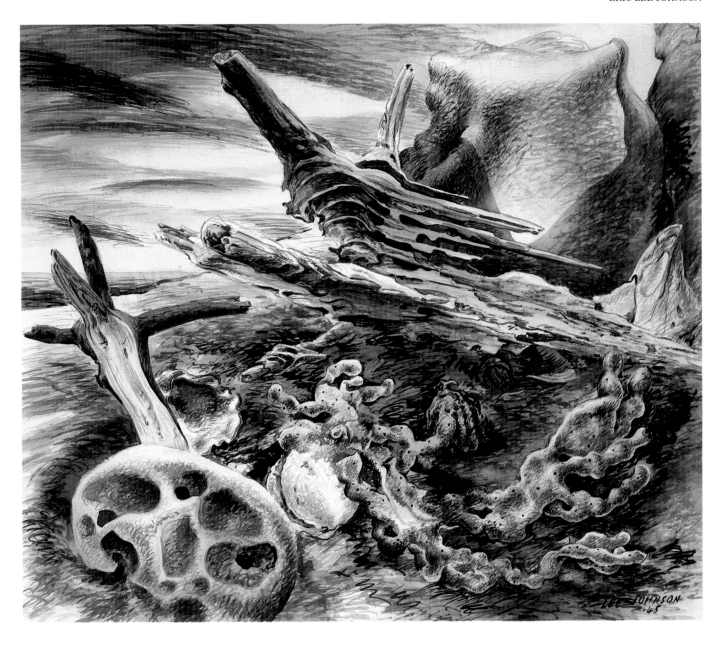

LEE-JOHNSON: AIREY 1969; DOCKING 1971; DUNN 1979a; FAIRBURN, MACKLE & SMITH 1981; HIPKINS 1948; LEE-JOHNSON 1947, 1952, 1953, 1958, 1969; McCORMICK 1956.

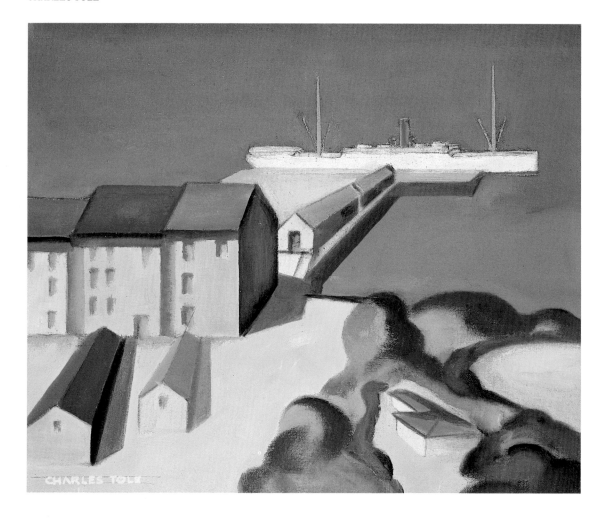

Rita Angus was a feminist and a pacifist, an unpopular stance during World War II, and she appeared before the Manpower Appeal Board in 1944 to justify her objection to working in a Christchurch rubber factory. In 1947, she described her aims as an artist: "To show to the present a peaceful way, and through devotion to visual art to sow some seed for possible maturity in later generations. I am Colonial, several generations, and for me New Zealand is, in essence, medieval. As a woman painter, I work to represent love of humanity and faith in mankind in a world, which is to me, richly variable and infinitely beautiful." [1]

This is not a particular Central Otago landscape, but rather a collage or composite derived from the watercolours and drawings she made in this region during 1938 and 1939. *Central Otago* is a brilliant example of Angus's unique realism, simultaneously modernist and historicist, in which she expresses the inseparability of landscape and buildings, primeval mountains and tilled fields, in a dynamic yet profoundly ordered composition. Roland Hipkins wrote of this painting: "Her vision carried her beyond the externals to the basic forms of the earth, and she can portray the emotional and social significance of man-made structures upon its surface... The sparkling light, so characteristic of New Zealand, is intensified, not by atmospheric realism but by the use of sharp, linear emphasis and by simplified and tonal gradations within the mass." [2]

*Unloading* appears to be a view of a "real" landscape, but like Angus's painting it is an invention based on Charles Tole's sketches of Auckland industries such as the Chelsea Sugar Refinery. While Angus was concerned with landscape's potential for unlocking history ("my own inheritance"), Tole's love of factories, power plants and petrol stations relates to his understanding that the urban industrial landscape, apart from its intrinsic formal beauty, could function as a symbol of modernity. The pair to *Unloading* is a similarly abstracted view of a factory in a landscape, titled *Industry*.

1 Angus 1947, p.68.
2 Hipkins 1948, p.111.

Charles TOLE   (1903-1988)
*Unloading*  1944
oil on canvas mounted on board, 257 x 304 mm
Auckland City Art Gallery, purchased 1989

Rita ANGUS   (1908-1970)
*Central Otago*  1940
oil on board, 350 x 548 mm
Auckland City Art Gallery,
bequest of Mrs Joyce Milligan, in memory of the late
Dr R.R.D. Milligan, 1987

TOLE, CHARLES:  DOCKING 1971.

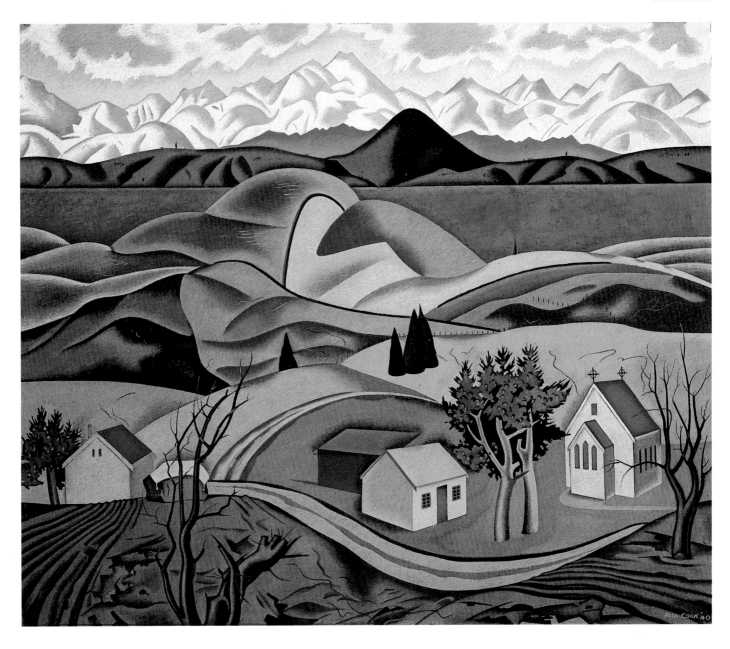

ANGUS: ANGUS 1947; BARR 1980; BROWNSON 1977; DOCKING 1971; HIPKINS 1948; HUTCHINGS 1983; PAUL 1983; PAUL et al. 1983.

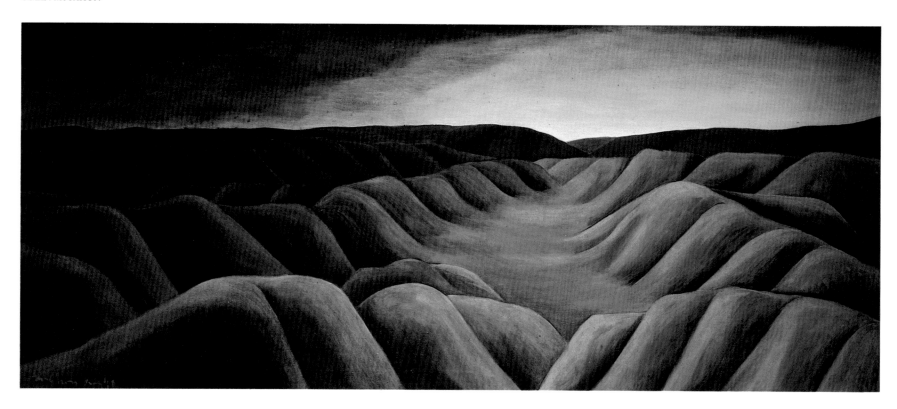

Colin McCAHON   (1919-1987)
*Takaka, night and day*  1948
oil on canvas mounted on board, 915 x 2130 mm
Auckland City Art Gallery,
presented by the Rutland Group, 1958

Doris LUSK   (1916-1990)
*Overlooking Kaitawa*  1948
oil on board, 575 x 688 mm
Robert McDougall Art Gallery, Christchurch

In 1972, Colin McCahon wrote about the origin of his *Takaka, night and day*: "The Takaka painting was painted round the corner of a room [his bedroom-studio at Doris Lusk's house], no one wall being itself long enough. Once more it states my interest in landscape as a symbol of place and also of the human condition. It is not so much a portrait of a place as such but is a memory of a time and an experience of a particular place." [1]  What McCahon remembered was the primeval essence of Takaka, and he introduced time as a biblical progression of night to day, darkness to light. In 1948, this was the largest painting McCahon had produced,

one which he intuitively knew required a monumental scale unheard of in Christchurch since the days of van der Velden.

Doris Lusk's *Overlooking Kaitawa*, also painted in 1948, is a very different kind of landscape. The hydro-electric station near Lake Waikaremoana had only just been opened, and Lusk depicts the construction village which housed the workers on this vast project. Although the eternal hills remain unchanged, they look down upon a landscape radically altered by the urban hunger for electricity.

1 McCahon & O'Reilly 1972, p.19.

McCAHON: BARR 1980; BIERINGA 1970, 1977-78; BRASCH 1950; BROWN 1977-78, 1984; BROWN, CURNOW, GREEN & JOHNSTON 1988; BROWN & KEITH 1969; CASELBERG 1977; CURNOW & O'REILLY 1977; DOCKING 1971; GREEN 1978, 1988-89; ISLANDS 1974; McCAHON 1966, 1977; PORSOLT 1963; STONES 1971.

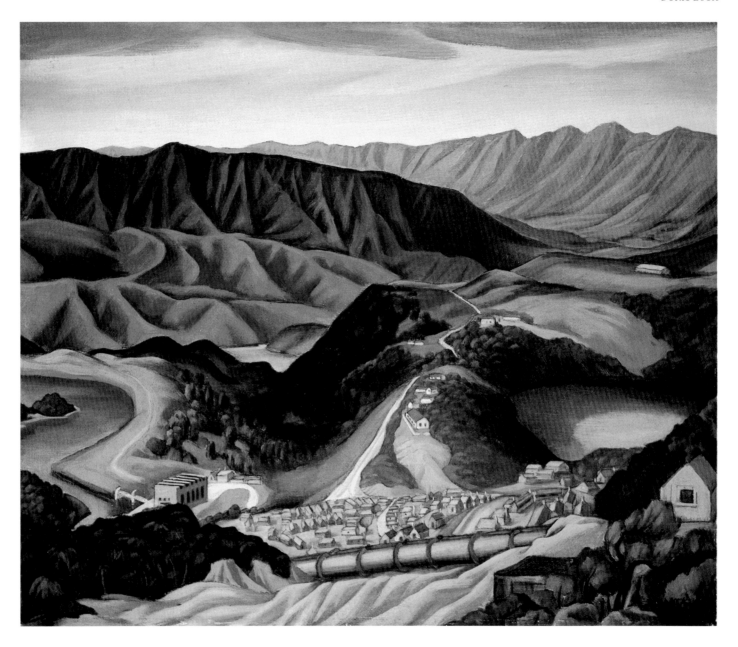

LUSK: BARR 1980; BEAVEN 1988; DOCKING 1971; KIRKER 1986; MILLAR 1973; SUMMERS 1986.

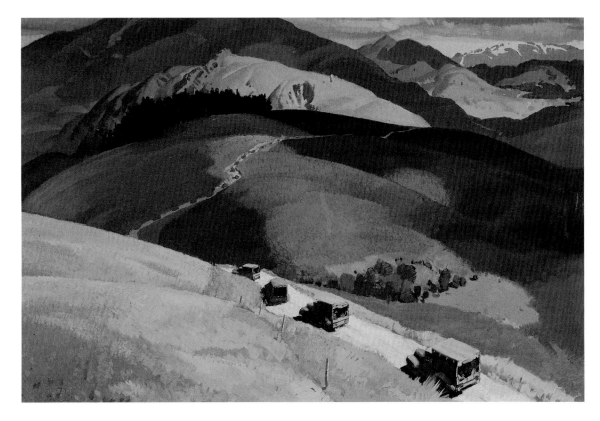

William Alexander Sutton studied at the Canterbury College School of Art. Landscape teacher Cecil Kelly took his students to work in the Canterbury hinterland, and Sutton acquired a formidable skill in depicting the high-country scenes which for Kelly were the *sine qua non* of New Zealand landscape. The high viewpoint of *Somewhere up country* is typical of Sutton's work of the mid-1940s, as is the sensitive portrayal of cloud shadows on the landforms. What sets this work apart, however, is its characterisation of Canterbury as a war zone. Part of Sutton's war work involved designing and painting camouflage for military installations in the South Island. The convoy of trucks snaking through the landscape, anonymously situated "somewhere", is an army exercise.

In 1947, Sutton left for a period of study in London. He returned two years later to take up a teaching position at Canterbury College. Landing at Auckland, he travelled south by the "Limited" and marvelled at New Zealand with new eyes. Particularly striking were the "mad little wooden churches which seemed to sum up best the spirit of a rural community of a couple of generations ago." [1] *Nor'wester in the cemetery* was inspired by the mortuary chapel in the Barbadoes Street Cemetery in Christchurch. Sutton depicts the New Zealand-gothic graveyard buffetted by the scorching north-west winds which descend on Canterbury in the summer.

Speaking at the opening of an historical survey of Canterbury painting, Bill Sutton proclaimed his allegiance to this most vigorous of all New Zealand's regional traditions. "Every time a Venetian painter raised his brush, that brush celebrated Venice, and I hope that I'm not being over-presumptuous in saying that something of the same sort has happened and *is* happening here in Canterbury. Here, if anywhere in New Zealand, a district has seized hold of the imagination of generations of painters. And this immense canvas has been presented to us with a few, but very bold marks upon it." [2]

W.A. SUTTON   (born 1917)
*Somewhere up country* 1944
oil on canvas, 700 x 1055 mm
Dunedin Public Art Gallery

W.A. SUTTON   (born 1917)
*Nor'wester in the cemetery* 1950
oil on canvas, 1517 x 1812 mm
Auckland City Art Gallery, purchased 1954

1 quoted in Millar 1973, p.10.
2 quoted ibid. p.14.

SUTTON: DOCKING 1971; HUTCHINGS 1973a, 1973b; MILLAR 1973; RENNIE 1985, 1986.

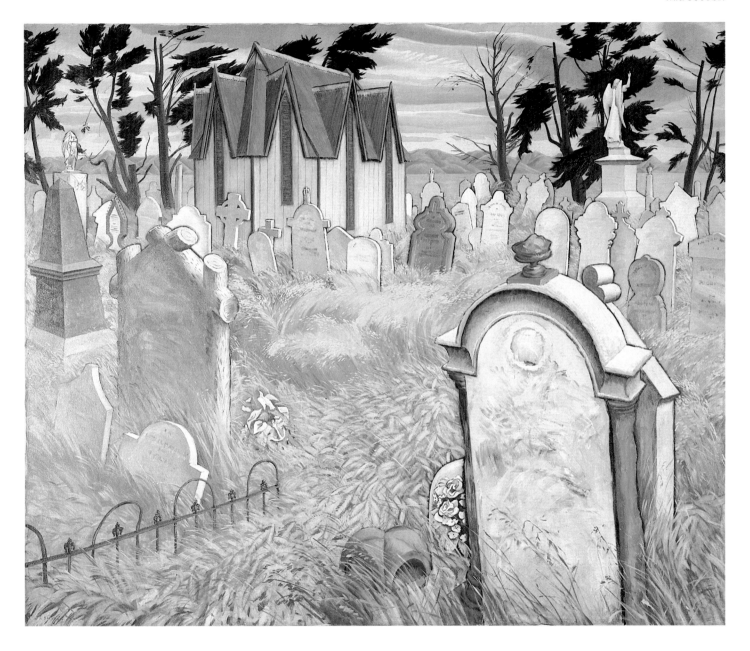

John TOLE (1890-1967)
*Through the trees* c.1953
oil on board, 400 x 450 mm
Fletcher Challenge collection, Wellington

Colin McCAHON (1919-1987)
*Flounder fishing, night, French Bay* 1956-57
enamel on board, 725 x 810 mm
Private collection, Auckland,
on loan to Auckland City Art Gallery

Milan MRKUSICH (born 1925)
*City lights* 1955
oil on cotton mounted on board, 760 x 925 mm
Auckland City Art Gallery, purchased 1989

A tendency towards a cubist-derived geometric abstraction emerged in Auckland painting of the 1950s. It ranges from the naturalism of John Tole's rendering of Newmarket rooftops seen through a screen of trees, obviously dependent on a knowledge of Paul Cézanne's work, to the complete abstraction of Milan Mrkusich's *City lights*. Here we are presented not with a landscape of representation, but rather with a kaleidoscopic gridwork of pure colour, reminiscent of Piet Mondrian's "Boogie-Woogie" paintings of the 1940s. A label on the reverse of *City lights* explains that the painting is "a study of the advancing & receding qualities of colours."

Colin McCahon's *Flounder fishing*, a nocturne inspired by lights reflected in French Bay, employs a similarly rigorous grid for its composition. McCahon's was a highly personal appropriation of cubism, which he claimed was first sparked by seeing reproductions in a copy of the *Illustrated London News*.

TOLE, JOHN: DOCKING 1971.

MRKUSICH:  BARR 1980;  CURNOW 1961;  DOCKING 1971;  DUNN & VULETIC 1972;  LEECH 1981;  LEECH & WILSON 1985.

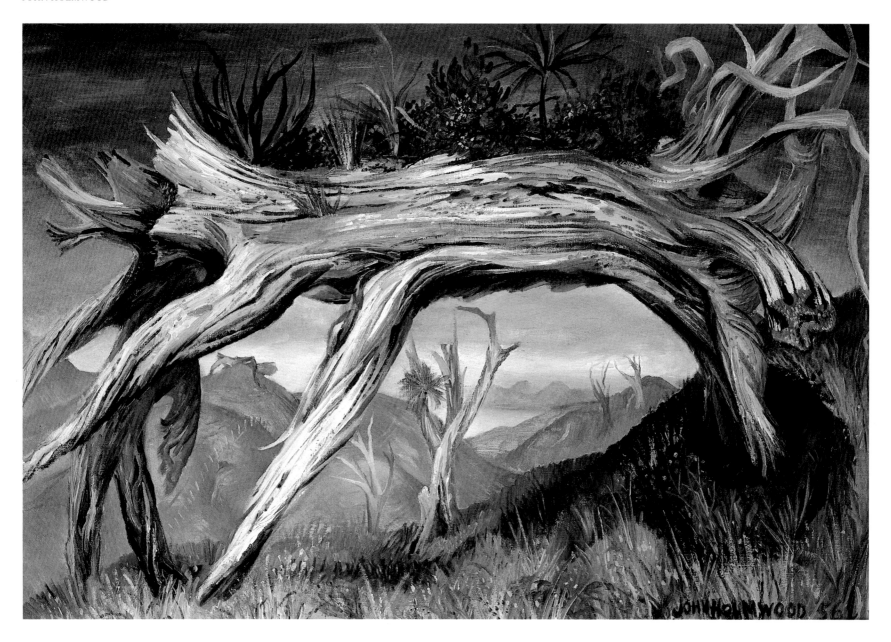

HOLMWOOD: JOHNSTON 1984.

John HOLMWOOD   (1910-1987)
*Relics of the forest, near Manukau Heads, south side*
1956
oil on canvasboard, 733 x 1065 mm
Auckland City Art Gallery,
purchased with Serra Trust funds, 1987

Rudolf GOPAS   (1913-1983)
*Shoreline* 1962
tempera on cardboard, 857 x 1092 mm
Auckland City Art Gallery, purchased 1967

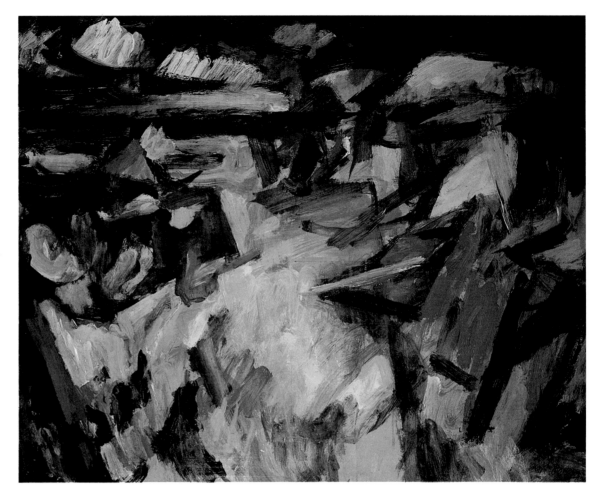

John Holmwood's career began in 1924, when he was
apprenticed to the Railways advertising studios at the
age of fourteen. "Here I was to learn a lot about pigment
at close quarters, mixing great drums of white lead, zinc
white, red lead, lamp black and grinding pounds of
various colours." [1]  These were the days when advertising
hoardings were hand-painted in oil colours.  He worked
with the Camouflage Unit during World War II, and also
collaborated with his wife on a 37-metre mural for the
Railway Court at the 1940 Centennial Exhibition.

After the war, Holmwood settled in Auckland, where he
developed an expressionist landscape style which relied
on rapid application of thickly textured oil paint. He
often turned his brush around to draw into the wet
paint, as here in his description of the distant fence.
*Relics of the forest* embodies Holmwood's memories of
Christopher Perkins's work, and especially of *Frozen
flames*.  But in its celebration of the ghostly relics'
ethereal beauty, his painting is also close to the neo-
romanticism of Eric Lee-Johnson's watercolours of the
1940s and 1950s.

Rudolf Gopas was born in Lithuania, where he attended
art school in the years before World War II.  After a
period as a refugee in Austria, he settled in New Zealand
in 1949.  His Baltic heritage led him to depict harbour
and shoreline imagery, and the spontaneous paint
handling reflected his experience of German expression-
ism. "The composition of 'Shoreline' is by movement
and tension rather than by tangible enclosed forms ...
Nature is dominated by the same forces no matter if it is
labelled New Zealand, Australia, Austria or Lithuania." [2]

As a teacher, Gopas was an important influence on a
generation of Christchurch art students, including Tony
Fomison.  His example lay not only in his passionately
expressive paintings, but also in his expounding of the
philosophical basis of his art.

1 typescript in Auckland City Art Gallery archive, quoted in Johnston
1984a, p.42.
2 quoted in Docking 1960, cat. no.12.

GOPAS: BARR 1980; DUNN 1983b; FURNISS 1987.

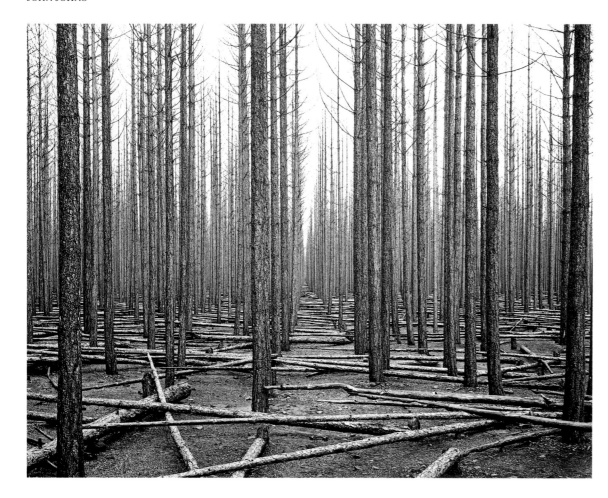

John JOHNS (born 1924)
*Burnt pine forest, Canterbury* 1955
gelatin silver photograph, 400 x 508 mm
Auckland City Art Gallery, purchased 1976

Brian BRAKE (1927-1988)
*Oriental Parade, Wellington* March 1960
cibachrome photograph (printed 1989), 416 x 612mm
Auckland City Art Gallery,
presented by a friend in memory of the artist, 1989

John Johns's photographs for the New Zealand Forest Service represent a forthright documentary realism. Unlike the earlier work of pictorialists such as George Chance, Johns's photographs are political in intention and relate to his passionate interest in forest management. Don Binney, defending native bush, wrote "I only bother to enter a state forest when I want to relieve myself"[1], but Johns demonstrates that the pine plantations are also a worthy subject embodying their own *genius loci*. As a forest worker, he appreciates the need for fast-growing exotic forests to take pressure off remaining stands of indigenous timber.

Brian Brake was New Zealand's most successful freelance photo-journalist, whose work appeared in such publications as *Life*, *Paris Match* and *National Geographic*, and was included in exhibitions at New York's Museum of Modern Art. People were the focus of his photographs, whether at a royal tour in Nigeria, the anniversary of the revolution in Peking, or Mother Teresa's home for the destitute in Calcutta. As with his friend and mentor, Henri Cartier-Bresson, Brake's talent lay in the sympathy sparked between his lens and its subjects.

For Brake, the line between "landscape" and "portraiture" was frequently blurred. The photographs he took at Oriental Bay one hot day in March 1960 celebrate New Zealanders' most significant social ritual: the day at the beach. Widespread sun-worship is a phenomenon of the twentieth century, and as future generations respond to the hazards of a depleted ozone layer, they may look back on documents such as this with the same incredulity we reserve for the modest attire of beachgoers depicted by earlier photographers.

1 Binney 1971, p.[4].

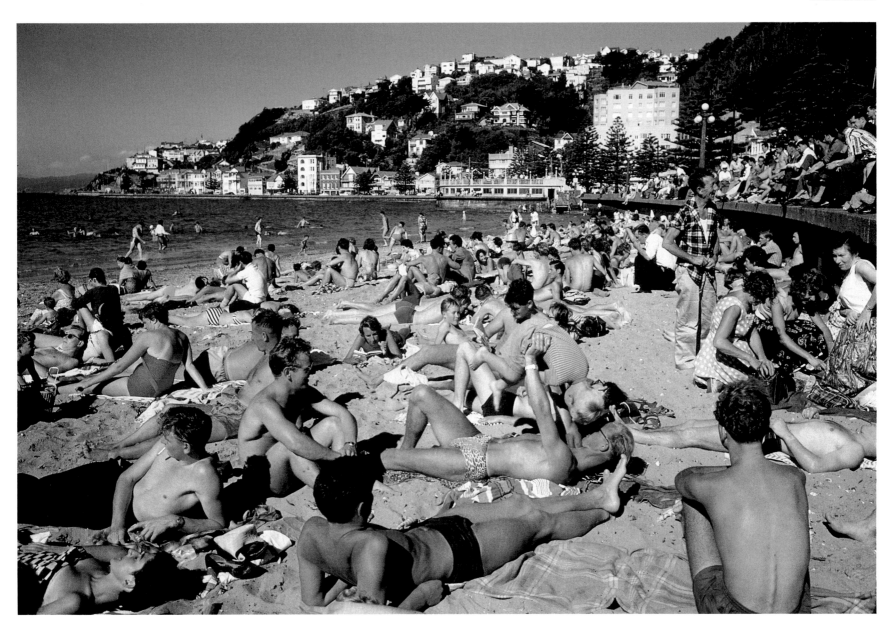

BRAKE: BRAKE & SHADBOLT 1963; MILLAR 1976.

Margot PHILIPS   (1907-1989)
*Coromandel coast*  1969
oil on canvasboard, 702 x 825 mm
Waikato Museum of Art and History

Don BINNEY   (born 1940)
*Sun shall not burn thee by day nor moon by night*  1966
oil and acrylic on canvas, 1168 x 1743 mm
Auckland City Art Gallery, purchased 1966

Ornithology was a childhood passion for Don Binney, and bird-watching provided his introduction to the natural world.  In a text he contributed to accompany his paintings in Barry Lett Galleries' *Earth/Earth* exhibition in 1971, Binney wrote: "New Zealand's remote and isolated ecology was one of the most sensitive and integral in the world.  Remarkably specialised birds filled roles more usually occupied by mammalians elsewhere.  Their whole existence was reciprocal to a delicate and specialised forest system.  It is a bit of a miracle, I guess, that such a relatively generous portion of this natural world has endured cycles of assault from man, fire, rat, axe, gun and Ministry of Works.  A lugubrious list of extinct species in this country is our stain of shame.  Is a garish prefab dwelling adequate compensation for a brace of kakapo?  An entire species of wren the fair price for a lighthouse?  The endurance of the huia quid pro quo for a visit by the Duke of Cornwall and York?" [1]

Binney belongs to a long tradition of New Zealand artists who have spoken out on the question of preserving landscapes in their unique state, and Alfred Sharpe and Josiah Martin are two earlier Auckland artists who fought on behalf of Binney's beloved Waitakere region.  Binney's pictures have appeared on the posters of many organisations, including the Waitakere Ranges Protection Society (1974 and 1975) and the Royal Forest and Bird Protection Society (1979 and 1980).

Margot Philips was a German Jewish refugee who began painting in her fifties, inspired by Colin McCahon's summer schools at the Auckland City Art Gallery.  She painted her memories of the Waikato or Coromandel, landscapes which she created centimetre by painstaking centimetre, "small brushstroke by small brushstroke, working row by row as if knitting, from the top of the canvas and gradually working towards the bottom." [2]  Resolving the foreground was always her great problem, yet it is also true that the spatial ambiguities resulting from this intuitive technique serve to enhance the visionary qualities of her best work.

1 Binney 1971, p.[4].
2 Paul 1983, p.4.

PHILIPS: PAUL 1983, 1988; WALKER 1987.

BINNEY: BARR 1980; BINNEY 1977, 1988; DOCKING 1971; GREEN 1972; HUTCHINGS 1973a; S. KEITH 1983.

Louise HENDERSON (born 1902)
*The lakes (triptych)* 1965
oil on board, 1520 x 2750 mm
Auckland City Art Gallery, purchased 1965

Patrick HANLY (born 1932)
*"Inside" the garden* 1968
oil and enamel on board, 1220 x 1220 mm
Auckland City Art Gallery, purchased 1989

Louise Henderson was born and grew up in Paris, where her father had been a secretary to the sculptor Auguste Rodin. She took the daring step of marrying a New Zealander, and in 1925 moved from Europe to Christchurch. During the 1930s she exhibited with The Group, and together with her friend Rita Angus made sketching excursions into the Canterbury landscape. Henderson's movement towards abstraction came after shifting to Auckland in 1950, and was confirmed by a year's study in Paris under the cubist master Jean Metzinger in 1952. *The lakes* belongs to a series she called "Elements - Air and Water", in which she explored an evocative lyricism akin to some contemporary American abstract expressionism. Yet unlike her associate Milan Mrkusich, Henderson stopped short of complete abstraction, preferring to search for her inspiration in the landscape about her.

Patrick Hanly's celebrated "molecular" paintings began with his experimentation in 1967 in a blacked-out studio, painting "blind" in an attempt to find a new direction for his painting. They also relate to several experiences under the influence of LSD, a psychedelic drug popular at this time among Auckland's literary and artistic avant-garde. He saw the domestic landscape, lush sub-tropical vegetation around his Mount Eden home, become a pulsating network of shapes and colours. When he later exhibited his "Energy Series", Hanly prefaced the catalogue with a quotation from William Blake, "The universe in a grain of sand and eternity in a flower", and ended with the statement, "Those who see only the garden see nothing."[1]

*"Inside" the garden*, and the many watercolours from this series, dispense with the notion of a world "out there", a landscape susceptible to formal arrangement by the artist. Instead, the painting consists of a continuum of interrelated sequences of pointillist paintwork. Hanly takes us "inside" the energy field of nature itself.

1 Millar 1974, p.[16].

HENDERSON: DOCKING 1971; GRIERSON 1988; KIRKER 1986; McCORMICK 1954.

HANLY: BARR 1980; BROWN & KEITH 1969; DOCKING 1971; HALEY 1989; ISLANDS 1974; KEITH 1979; MILLAR 1974; SMART 1981.

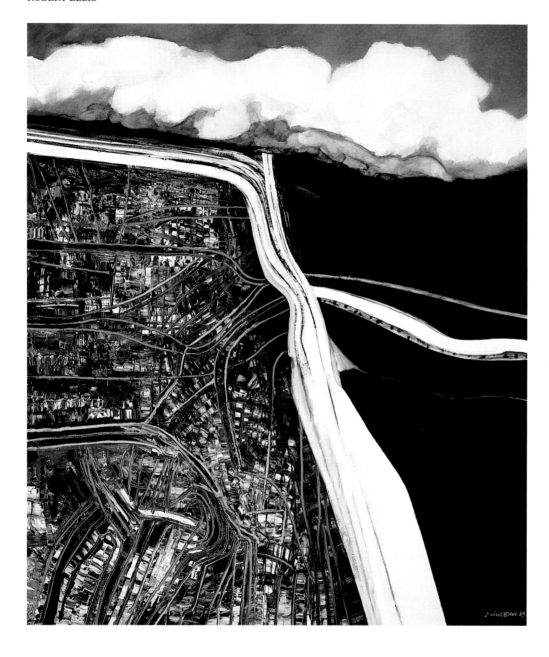

Robert ELLIS   (born 1929)
*Motorway/city*  1969
oil on board, 1233 x 1066 mm
Auckland City Art Gallery, purchased 1969

Rita ANGUS   (1908-1970)
*Fog, Hawke's Bay*  1966-68
oil on board, 597 x 889 mm
Auckland City Art Gallery, purchased 1969

*Fog, Hawke's Bay* is based on Rita Angus's experience of travelling from Wellington to visit her family in Napier. Working from ballpoint sketches she made in the front seat of a Newman's bus, she created a "total image" incorporating multiple viewpoints. In a sketchbook from the 1960s, Angus noted her admiration of the cubist painters' deconstruction of form and time.  "The Cubist analysed this apparent unity of nature & found that it in fact consisted of separate facets or separate & distinct moments of vision.  He slowed down the film & found it was composed of single, static images.  The fragmented facet of a form which he sees is in truth the total image which the eye & mind perceive in the moment of vision."[1]

A graduate of London's Royal College of Art, Robert Ellis arrived in Auckland in 1957 to take up a lectureship at Elam School of Art.  His dramatic paintings of the late 1960s, of vast conurbations viewed from above, are a painterly response to New Zealand's rapid urbanisation of the past few decades.  In Auckland, Ellis saw the developing motorway system demolish vast tracts of housing and push its way through the remaining bush in Grafton Gully.  Nevertheless, he does not depict Auckland or any specific city, but instead exploits the pictorial possibilities of the city as an organism with a life of its own.

1 quoted by Kirker in Paul et al. 1983, p.60.

ELLIS: BARR 1980; DOCKING 1971.

Robin MORRISON   (born 1944)
*Hotel, Ross, West Coast*  1979
cibachrome photograph, 266 x 399 mm
Auckland City Art Gallery, purchased 1983

Robin WHITE   (born 1946)
*Fish & chips, Maketu*  1975
oil on canvas, 609 x 914 mm
Auckland City Art Gallery, purchased 1975

Peter SIDDELL   (born 1935)
*A place to stand*  1978
acrylic on canvas, 1102 x 1615 mm
Dunedin Public Art Gallery

Robin Morrison's *Hotel, Ross* is a plate from his book of colour photographs *The South Island of New Zealand: From the Road*, the result of over 30,000 kilometres' travel.  His quirky vision of rural grandeur and decay is interspersed by some sensitive portraits.  This transformation of the banal can also be seen in Robin White's painting, which assimilates Don Binney's hard-edged style and bright  light, but finds its endangered species within the suburban landscape.  Here she memorialises the fish-and-chip shop, still integral to small-town gastronomic culture, but threatened by the exotic fast-food chains which have colonised the entire world.

Nostalgia is also at the heart of Peter Siddell's immaculate representation of a city which looks like it might be Auckland, but on closer inspection is revealed to be a scrambled simulacrum.  The Latin inscription on the mirror-glass building is from Virgil's *Georgics* (iii.284), and translates as "Meanwhile time is flying, flying never to return."  Now that Auckland has been inundated with mirror-glass towers, it is easy to forget that in the late 1970s the first examples were greeted with almost unanimous admiration.

MORRISON: BOSWORTH 1981; MORRISON 1981.
WHITE: HUTCHINGS 1973a; ISLANDS 1974; KIRKER 1986; TAYLOR & BROWN 1981; WHITE 1977.

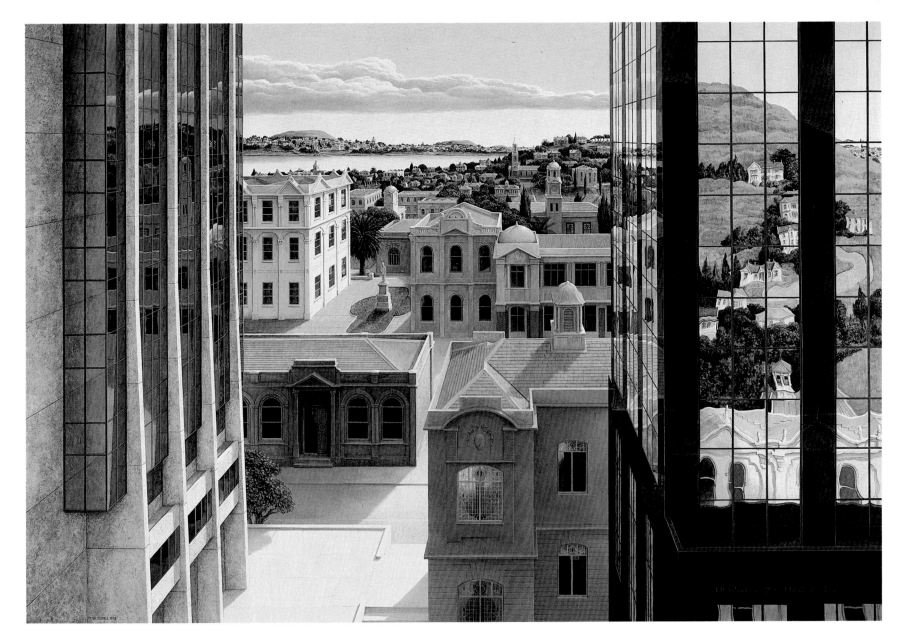

SIDDELL: BINNEY 1988; SIDDELL 1987.

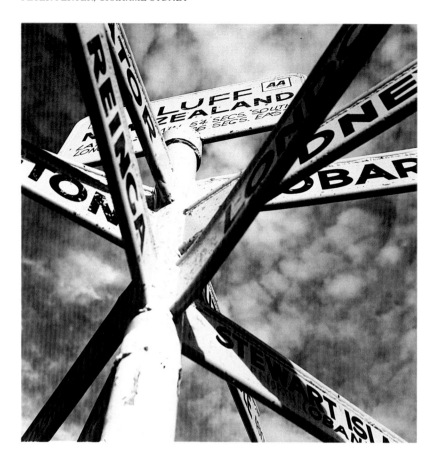

Grahame Sydney's painstaking egg-tempera paintings of the 1970s celebrate the unique qualities of Central Otago, where he was then living. *Cross* presents a landscape in the Clutha Valley, which is still under threat of flooding from a gigantic hydro-electric project. A railway-crossing sign becomes an "X" which cancels the landscape beyond. The signpost in Peter Peryer's *Bluff*, instead of framing a view, is itself the landscape. One direction we receive is "Equator", a disregarded zone in our age of air-travel.

Tony Fomison's ambiguous landscapes derive not from any external locations, but from the dark recesses of the imagination. Who is the fugitive, and from what fate is he or she escaping? Is this the remote past of Aotearoa, or do we have here a glimpse of some post-apocalyptic future? Together with the persistent tradition of hard-edged realism, dreamscapes such as Fomison's point to the continuing strengths of New Zealand's tradition of landscape art.

Peter PERYER   (born 1941)
*Bluff*  1985
gelatin silver photograph, 358 x 354 mm
Auckland City Art Gallery, purchased 1989

Grahame SYDNEY   (born 1948)
*Cross*  October-November 1976
tempera on gesso on board, 624 x 675 mm
Auckland City Art Gallery, purchased 1980

Tony FOMISON   (1939-1990)
*The fugitive*  1980-82
synthetic resin on hessian mounted on board,
1220 x 1830 mm
BNZ collection, Wellington

PERYER: BARR 1985; HUTCHINS 1979; IRELAND 1984; JOHNSTON 1984; PERYER 1977-78.
SYDNEY: DUNN 1988; SYDNEY 1977, 1978.

FOMISON: BARR 1979, 1980; CARTWRIGHT 1989; JOHNSTON 1984; ROSS 1976.

# SELECT BIBLIOGRAPHY

The bibliography is built around the artists represented in this book. It also includes a wide selection of general essays relating to New Zealand landscape art.

Readers seeking accessible biographical information on the artists and their careers should note Una Platts's indispensable dictionary *Nineteenth Century New Zealand Artists*. There is no comparable guide to twentieth-century artists, but useful sources are Gil Docking's *Two Hundred Years of New Zealand Painting*, Jim and Mary Barr's *New Zealand Painters (A-M)*, and Anne Kirker's *New Zealand Women Artists*.

ADAMS, GRACE. "Afternoon tea with Olivia Spencer Bower." *Art New Zealand*, 26, 1983, pp.20-21.

AIREY, DEIRDRE. "An approach to the work of Eric Lee-Johnson." *Landfall*, 23, 4, (92), 1969, pp.374-380.

ALCOCK, LUCY. "As Chance would have it: the photographs of George Chance (1885-1963)." *Art New Zealand*, 47, 1988, pp.96-98.

ALLEN, W.H. "Impressions of New Zealand art." *Art in New Zealand*, 1, 4, (4), June 1929, pp.213-216.

ALLEN, W.H. "R.N. Field ARCA: an appreciation." *Art in New Zealand*, 10, 4, (40), June 1938, pp.187-196.

ANGAS, G.F. *The New Zealanders Illustrated*. Thomas M'Lean, London 1847 = Angas 1847a.

ANGAS, G.F. *Savage Life and Scenes in Australia and New Zealand*. (2 vols), Smith/Elder, London, 1847 = Angas 1847b.

ANGUS, RITA. "Rita Angus." *Year Book of the Arts in New Zealand*, 3, 1947, pp.67-69.

ANONYMOUS. "Note on Archibald Nicoll." *Art in New Zealand*, 4, 16, (16), June 1932, pp.236-245.

ANONYMOUS. "Olivia Spencer Bower: retrospective exhibition 1968." *Ascent*, 3, 1969, pp.46-55.

ATKINSON, ESMOND. "The art of J.C. Richmond." *Art in New Zealand*, 4, 15, (15), March 1932, pp.170-191.

BAGNALL, A.G. "James Crowe Richmond (1822-98)", in McLintock 1966, vol. 3, pp.78-80.

BARNETT, GERALD. "M.T. Woollaston: the later works." *Art New Zealand*, 44, 1987, pp.72-77.

BARR, JIM. *Tony Fomison: a Survey of Painting and Drawing from 1961 to 1979* (exhibition catalogue), Dowse Art Gallery, Lower Hutt, 1979.

BARR, JIM & MARY. *Contemporary New Zealand Painters (A-M)*. Alister Taylor, Martinborough, 1980.

BARR, JIM & MARY. *Rudolf Gopas* (exhibition catalogue), Govett-Brewster Art Gallery, New Plymouth, 1982.

BARR, JIM & MARY. *Peter Peryer Photographs* (exhibition catalogue), Sarjeant Gallery, Wanganui, 1985.

BEAGLEHOLE, J.C. "A note on T.A. McCormack." *Art in New Zealand*, 8, 4, (32), June 1936, pp.197-201.

BEAVEN, LISA. "Doris Lusk: attitudes to the land 1934-84." Unpublished M.A. thesis, University of Canterbury, 1988.

BEGG, A. CHARLES & BEGG, NEIL C. *Dusky Bay*. Whitcombe & Tombs, Christchurch, 1966; revised edition, 1968.

BEGG, A. CHARLES & BEGG, NEIL C. *James Cook and New Zealand*. Government Printer, Wellington, 1970.

BELICH, JAMES. *The New Zealand Wars, and the Victorian Interpretation of Racial Conflict*. Auckland University Press, Auckland, 1986.

BELL, LEONARD. "G.F. von Tempsky: the man and the artist." *Art New Zealand*, 10, 1978, pp.21-22.

BELL, LEONARD. "A letter from von Tempsky." *Art New Zealand*, 21, 1981, pp.42-45.

BELL, LEONARD. "Putting the record straight: Gordon Walters." *Art New Zealand*, 27, 1983, pp.42-45.

BELL, LEONARD. "Nicholas Chevalier: the fortunes and functions of his paintings." *Art New Zealand*, 44, 1987, pp.78-81.

BETT, ELVA. *New Zealand Art: a Modern Perspective*. Reed Methuen, Auckland, 1986.

BIERINGA, LUIT. "Two New Zealand painters: the thirties and forties - foundations and changes in the work of M.T. Woollaston and Colin McCahon." Unpublished M.A. thesis, University of Auckland, 1970.

BIERINGA, LUIT. *M.T. Woollaston: Works 1933-1973* (exhibition catalogue), Manawatu Art Gallery, Palmerston North, 1973.

BIERINGA, LUIT. "There is only one direction." *Art New Zealand*, 8, 1977-78, pp.32-35.

BILLCLIFFE, ROGER. *The Glasgow Boys: the Glasgow School of Painting 1875-1895*. John Murray, London, 1985.

BINNEY, DON. "The dreadful hubris of mankind…" Text in *Earth/Earth* (exhibition catalogue), Barry Lett Galleries, Auckland, 1971.

BINNEY, DON. "A benevolent by-product." *Art New Zealand*, 7, 1977, pp.43-44.

BINNEY, DON. "Landscape reassertions: some Auckland artists." *Art New Zealand*, 48, 1988, pp.72-74.

BLACKLEY, ROGER. "New light on Alfred Sharpe." *Art New Zealand*, 7, 1977, pp.46-51.

BLACKLEY, ROGER. "Writing Alfred Sharpe." Unpublished M.A. thesis, University of Auckland, 1978.

BLACKLEY, ROGER. "John Guise Mitford: a topographical painter of the 1840s." *Art New Zealand*, 27, 1983, pp.46-51.

BLACKLEY, ROGER. "Lance-Sergeant John Williams: military topographer of the Northern War." *Art New Zealand*, 32, 1984, pp.50-53.

BLACKLEY, ROGER. "George O'Brien: pavilioned in splendour." *Art New Zealand*, 39, 1985, pp.54-57.

BLACKLEY, ROGER. "Blomfield's terraces." *Turnbull Library Record*, 20, 1, May 1987, pp.9-16.

BLAIKIE, J.A. "Art in New Zealand." *Magazine of Art*, 1887, pp.32-36.

BLOMFIELD, CHARLES. "The Society of Arts Exhibition." *Auckland Evening Star*, 20 April 1883, p.3.

BLOMFIELD, CHARLES. "The lost terraces: gone forever." *New Zealand Herald*, 1 February 1902, supplement, p.1.

BLOMFIELD, CHARLES. "What is art? The power of the picture." *New Zealand Herald*, 3 October 1925, supplement, p.1.

BOOTH, L.H. "P. van der Velden." *Art in New Zealand*, 3, 9, (9), September 1930, pp.9-23.

BOSWORTH, RHONDDA. "Robin Morrison." *Art New Zealand*, 21, 1981, pp.29-31.

BRAKE, BRIAN & SHADBOLT, MAURICE. *New Zealand: Gift of the Sea*. Whitcombe & Tombs, Christchurch, 1963.

BRASCH, CHARLES. "A note on the work of Colin McCahon." *Landfall*, 4, 4, (16), 1950, pp.337-339.

BRIDGE, CYPRIAN. "Journal of events on expedition to New Zealand commencing 4 April 1845." Manuscript copy of journal, Alexander Turnbull Library = Bridge MS.

BROWN, GORDON H. & KEITH, HAMISH. *An Introduction to New Zealand Painting 1939-1967*. Collins, Auckland, 1969; revised and enlarged, 1982.

BROWN, GORDON H. "Signor Nerli the painter." *Auckland City Art Gallery Quarterly*, 45, 1969, pp.3-15.

BROWN, GORDON H. *The Ferrier-Watson Collection of Watercolours by John Kinder* (exhibition catalogue), Waikato Art Gallery, Hamilton, 1970.

BROWN, GORDON H. *New Zealand Painting 1900-1920: Traditions and Departures* (exhibition catalogue), Hocken Library/Queen Elizabeth II Arts Council of New Zealand, Wellington, 1972.

BROWN, GORDON H. "Advances in painting." *New Zealand's Heritage*, 100, 1973, pp.2778-2783.

BROWN, GORDON H. *New Zealand Painting 1920-1940: Adaptation and Nationalism* (exhibition catalogue), Robert McDougall Art Gallery/Queen Elizabeth II Arts Council of New Zealand, Wellington, 1975.

BROWN, GORDON H. "Colin McCahon: a basis for understanding." *Art New Zealand*, 8, 1977-78, pp.26-31.

BROWN, GORDON H. *New Zealand Painting 1940-1960: Conformity and Dissension* (exhibition catalogue), Robert McDougall Art Gallery/Elizabeth II Arts Council of New Zealand, Wellington, 1981.

BROWN, GORDON H. *Colin McCahon: Artist*. A.H. & A.W. Reed, Wellington, 1984.

BROWN, GORDON H. "A reply to Francis Pound's 'Harsh clarities' in *Parallax #3*." *Bulletin of New Zealand Art History*, 9, 1985, pp.105-108.

BROWNSON, RONALD. "Rita Angus." Unpublished M.A. thesis, University of Auckland, 1977.

BROWNSON, RONALD & DUNN, MICHAEL. *John Kinder Photographs* (exhibition catalogue), Auckland City Art Gallery, 1985.

BRUCE, CANDICE. *Eugen von Guérard* (exhibition catalogue), Australian National Gallery/Australian Gallery Directors Council, 1980.

BRUCE, CANDICE; COMSTOCK, EDWARD & McDONALD, FRANK. *Eugene von Guérard: a German Romantic in the Antipodes*. Alister Taylor, Martinborough, 1982.

BRUCE, CANDICE & COMSTOCK, EDWARD. "Johann Joseph Eugen (Eugene) von Guérard (1811-1901)", in Kerr 1984, pp.319-321.

BURNS, ANGELA. *George O'Brien: an Exhibition of 22 Works from the Early Settlers Museum* (exhibition catalogue), Otago Early Settlers Museum, Dunedin, 1982.

CARBERY, A.D. "D.K. Richmond: an appreciation." *Art in New Zealand*, 8, 1, (29), September 1935, p.9.

CARTWRIGHT, GARTH. "Recent work by Tony Fomison." *Art New Zealand*, 52, 1989, pp.66-69.

CASELBERG, JOHN. "Colin McCahon's panels, 'The Song of the Shining Cuckoo'." *Islands*, 5, 4, 1977, pp.404-408.

CHEVALIER, CAROLINE. "A short description of a journey across the Southern Island of New Zealand ... 1866." Manuscript copy of journal, Alexander Turnbull Library = Chevalier MS.

COLLINS, R.D.J. "Dunedin in the eighteen-nineties." *Art New Zealand*, 2, 1976, pp.28-32.

COLLINS R.D.J. "George O'Brien 1821 to 1888." *Art New Zealand*, 3, 1976-77, pp.21-28.

COLLINS, R.D.J. *Pictures of Southern New Zealand*. John McIndoe, Dunedin, 1979.

COLLINS, R.D.J. & ENTWISLE, PETER. *Pavilioned in Splendour: George O'Brien's Vision of Colonial New Zealand* (exhibition catalogue), Dunedin Public Art Gallery, 1986.

COLLINS, R.D.J. & CURTIS, WENDY-ANNE. *The New Zealand Exhibition, 1865: Documents on the Fine Arts*. University of Otago, Dunedin, 1988.

COLLINS, R.D.J.; GARRITY, T.P. & ENTWISLE, ROSEMARY. *John Buchanan 1819-98: Artist, Botanist and Explorer* (exhibition catalogue), Hocken Library, Dunedin, 1988.

COLONIAL & INDIAN EXHIBITION. *Catalogue of New Zealand Exhibits*. William Clowes & Sons, London, 1886.

COUNIHAN, NOEL. "T.A. McCormack's water colours." *Art in New Zealand*, 12, 2, (46), December 1939, pp.101-102.

COWAN, JAMES. *The New Zealand Wars: a History of the Maori Campaigns and the Pioneering Period*. (2 vols.), 1922, revised version, Government Printer, Wellington, 1983.

CURNOW, HEATHER. "The New Zealand paintings of William Strutt." *Art New Zealand*, 13, 1979, pp.46-51.

CURNOW, HEATHER. *The Life and Art of William Strutt 1825-1915*. Alister Taylor, Martinborough, 1980 = Curnow 1980a.

CURNOW, HEATHER. *William Strutt* (exhibition catalogue), Australian Gallery Directors Council/Art Gallery of New South Wales, Sydney, 1980 = Curnow 1980b.

CURNOW, HEATHER. "Nicholas Chevalier 1828-1902." *Art & Australia*, 18, 3, 1981, pp.255-261.

CURNOW, WYSTAN. "Milan Mrkusich." *Landfall*, 15, 2, (58), 1961, pp.171-173.

CURNOW, WYSTAN & O'REILLY, R.N. *McCahon's "Necessary Protection"* (exhibition catalogue), Govett-Brewster Art Gallery, New Plymouth, 1977.

CURNOW, WYSTAN. *Putting the Land on the Map: Art and Cartography in New Zealand since 1840* (exhibition catalogue), Govett-Brewster Art Gallery, New Plymouth, 1989.

CURRIE, BETTY. "Signor Nerli." *Art & Australia*, 16, 1, 1978, pp.55-60.

DAY, MELVIN N. "Nicholas Chevalier 1828-1902." *Art New Zealand*, 17, 1980, pp.64-67.

DAY, MELVIN N. *Nicholas Chevalier, Artist: his Life and Work with Special Reference to his Career in New Zealand and Australia*. Millwood Press, Welllington, 1981.

DAY, MELVIN N. "Nicholas Chevalier (1828-1902)", in Kerr 1984, pp.144-146.

DIEFFENBACH, ERNST. *Travels in New Zealand*. (2 vols.), Smith/Elder, London, 1843.

DOCKING, GIL. *New Zealand Art of the Sixties: a Royal Visit* (exhibition catalogue), Queen Elizabeth II Arts Council of New Zealand, Christchurch, 1970.

DOCKING, GIL. *Two Hundred Years of New Zealand Painting*. A.H. & A.W. Reed, Wellington, 1971.

DUNCAN, JOHN CAM. "New Zealand painters; the late A.W. Walsh: an appreciation." *Art in New Zealand*, 1, 3, (3), March 1929, pp.169-170.

DUNN, MICHAEL. *W.H. Allen Retrospective* (exhibition catalogue), Dunedin Public Art Gallery, 1970.

DUNN, MICHAEL. "Gopas: remarks on his style and development." *Artis*, 1, 1, 1971, pp. [2-4].

DUNN, MICHAEL & VULETIC, PETAR L. *Milan Mrkusich Paintings 1946-1972* (exhibition catalogue), Auckland City Art Gallery, 1972.

DUNN, MICHAEL. "Notes on Nairn in Glasgow." *Bulletin of New Zealand Art History*, 5, 1977, pp.10-14.

DUNN, MICHAEL. "The enigma of Gordon Walters' art." *Art New Zealand*, 9, 1978, pp.56-63.

DUNN, MICHAEL. "Frozen flame and slain tree: the dead tree theme in New Zealand art of the thirties and forties." *Art New Zealand*, 13, 1979, pp.41-45 = Dunn 1979a.

DUNN, MICHAEL. *Robert Nettleton Field Retrospective* (exhibition catalogue), Dunedin Public Art Gallery, 1979 = Dunn 1979b.

DUNN, MICHAEL. "Gordon Walters: some drawings from the 1940s." *Bulletin of New Zealand Art History*, 8, 1980, pp.2-11.

DUNN, MICHAEL. *Gordon Walters:* (exhibition catalogue), Auckland City Art Gallery, 1983 = Dunn 1983a.

DUNN, MICHAEL. "Rudolf Gopas: a teacher and painter in retrospect." *Art New Zealand*, 27, 1983, pp.28-33 = Dunn 1983b.

DUNN, MICHAEL. "The art of Gordon Walters." Unpublished Ph.D. thesis, University of Auckland, 1984.

DUNN, MICHAEL. *John Kinder: Paintings and Photographs*. SeTo, Auckland, 1985.

DUNN, MICHAEL. "Impressionist painting in New Zealand." *Art & Antiques* 1, 1985-86, pp.14-15, 40.

DUNN, MICHAEL. "The art of Grahame Sydney." *Art New Zealand*, 47, 1988, pp.76-78.

DUNN, MICHAEL. "Girolamo Nerli: an Italian painter in New Zealand." *Art New Zealand*, 49, 1988-89, pp.60-65.

EARLE, AUGUSTUS. *Narrative of a Residence in New Zealand*. Longman, London, 1832; revised and edited by E.H. McCormick, Oxford University Press, Oxford, 1966.

EARLE, AUGUSTUS. *Sketches Illustrative of the Native Inhabitants and Islands of New Zealand*. Robert Martin, London, 1838.

EASDALE, NOLA. *Kairuri, the Measurer of Land: the Life of the 19th Century Surveyor Pictured in his Art and Writings*. Highgate/Price Milburn, Petone, 1988.

EDWARDS, STANLEY·H. & MAGURK, JOHN. "James Nairn: artist." *Art in New Zealand*, 12, 4, (48), June 1940, pp.220-225.

ENTWISLE, PETER. *William Mathew Hodgkins and his Circle* (exhibition catalogue), Dunedin Public Art Gallery, 1984.

ENTWISLE, PETER; DUNN, MICHAEL & COLLINS, R.D.J. *Nerli: an Exhibition of Paintings and Drawings* (exhibition catalogue), Dunedin Public Art Gallery, 1988.

ESPLIN, T. "John Gully (1819-88)", in McLintock 1966, vol.1, pp.885-886.

ESPLIN, T. "James McLachlan Nairn (1859-1904)", in McLintock 1966, vol.2, pp.618-619.

ESPLIN, T. "Archibald Frank Nicoll (1886-1953)", in McLintock 1966, vol 2, pp.689-690.

FAIRBURN, A.R.D. "Some aspects of N.Z. art and letters." *Art in New Zealand*, 6, 4, (24), June 1934, pp.213-218.

FAIRBURN, A.R.D. "Some reflections on New Zealand painting." *Landfall*, 1, 1, (1), 1947, pp.49-56.

FAIRBURN, G.E.; MACKLE, ANTHONY & SMITH, CAMPBELL. *Lee-Johnson 81* (exhibition catalogue), Waikato Art Museum, Hamilton, 1981.

FIELD, R.N. "Art and the public: colour." *Art in New Zealand*, 13, 2, (50), December 1940, pp.95-97.

FIELD, R.N. "Art and the public: line." *Art in New Zealand*, 13, 3, (51), March 1941, pp.144-146.

FIELD, R.N. "Art and the public: form." *Art in New Zealand*, 13, 4, (52), June 1941, pp.193-194.

FIELD, R.N. "Art and the public: design." *Art in New Zealand*, 14, 1, (53), September 1941, pp.39-40.

FOSTER, B.J. "William Thomas Locke Travers (1819-1903)", in McLintock 1966, vol.3, p.445.

FOX, WILLIAM. *The Six Colonies of New Zealand*. John W. Parker, London, 1851.

FRAME, EDITH. "John Alexander Gilfillan (1793-1864)", in Kerr 1984.

FRASER, ROSS. "Robert Nettleton Field." *Art New Zealand*, 19, 1981, pp.28-33.

FURNISS, KATHERINE. "Rudolf Gopas (1913-85)." Unpublished M.A. thesis, University of Canterbury, 1987.

GARDINER, ROBERT B.K. "Margot Philips: a note on her recent exhibition at the New Vision Gallery." *Artis*, 2, 3, 1972, pp.18-20.

GARRETT, JANE. *An Artist's Daughter: with Christopher Perkins in New Zealand 1929-34*. Shoal Bay Press, Auckland, 1986.

GIBB, JOHN. "The veteran Canterbury artist: a chat with Mr John Gibb." *Canterbury Times*, 12 December 1900, p.49.

GORDON, BRIAR & STUPPLES, PETER. *Charles Heaphy*. Pitman, Wellington 1987.

GOUDIE, R.C. & RUHEN, OLAF. *New Zealand, Land for the Artist: Paintings by Robert Johnson*. Legend Press, Sydney, 1953.

GREEN, TONY. "Binney's black lines." *Arts & Community*, 8, 5, May 1972, pp.12-13.

GREEN, TONY. "Colin McCahon's 'Necessary Protection' in Auckland" and "Notes on the paintings 1971-1976." *Art New Zealand*, 11, 1978, pp.32-35.

GREEN, TONY. "McCahon made difficult." *Art New Zealand*, 49, 1988-89, pp.54-57.

GRIERSON, ELIZABETH. "Louise Henderson." *Art New Zealand*, 46, 1988, pp.77-81.

GULLY, JOHN SIDNEY. *New Zealand's Romantic Landscape: Paintings by John Gully*. Millwood Press, Wellington, 1984.

HACKFORTH-JONES, JOCELYN. *Augustus Earle: Travel Artist. Paintings and Drawings in the Rex Nan Kivell Collection, National Library of Australia*. Alister Taylor, Martinborough, 1980.

HACKFORTH-JONES, JOCELYN. "Augustus Earle (1793-1838)", in Kerr 1984, p.223-225.

HALL, DAVID. "T.A. McCormack: a retrospective exhibition." *Landfall*, 13, 2, (50), 1959, pp.168-169.

HALL, T.D.H. "The art of Nugent Welch." *Art in New Zealand*, 6, 1, (21), September 1933, pp.8-23.

HAMLIN, B.G. "John Buchanan (1819-98)", in McLintock 1966, vol.1, pp.264-265.

HEAPHY, CHARLES. *Narrative of a Residence in Various Parts of New Zealand*. Smith/Elder, London, 1842.

HEAPHY, CHARLES. "Account of an exploring expedition to the south-west of Nelson", and "Notes of an expedition to Kawatiri and Araura, on the western coast of the Middle Island", in Taylor 1959, pp.188-249.

HIPKINS, ROLAND. "N.Z. Academy of Fine Arts exhibition." *Art in New Zealand*, 7, 2, (26), December 1934, pp.61-64.

HIPKINS, ROLAND. "The art of T.A. McCormack." *Art in New Zealand*, 8, 4, (32), June 1936, pp.189-196.

HIPKINS, ROLAND. "Contemporary art in New Zealand." *The Studio*, April 1948, pp.102-120.

HIPWELL, ARTHUR C. "Adele Younghusband: a New Zealand surrealist." *Art in New Zealand*, 14, 2, (54), December 1941, pp.83-86.

HOCKEN LIBRARY. *Three Generations: Paintings by J.C. Richmond, D.K. Richmond, E.H. Atkinson* (exhibition catalogue), Hocken Library, Dunedin, 1966.

HODGKINS, W.M. "A history of landscape art and its study in New Zealand." Lecture to the Otago Institute, published *Otago Daily Times*, 20 November 1880, p.l. (supplement). Reprinted in Entwisle 1984, pp.156-162.

HOLMES, CHARLES (ed.). *Art of the British Empire Overseas*. The Studio, London, 1917.

HUTCHINGS, PATRICK. "Young contemporary New Zealand realists." *Art International*, 17, 3, March 1973, pp.13-21 = Hutchings 1973a.

HUTCHINGS, PATRICK. "W.A. Sutton retrospective." *Islands*, 2, 1, 1973, pp.65-75 = Hutchings 1973b.

HUTCHINGS, PATRICK. "Landscape and figures, tradition and talent." *Landfall*, 37, 2, (146), 1983, pp.167-172.

HUTCHINGS, PATRICK. "Gordon Walters: absolute abstraction and 'topicality'." *Landfall*, 38, 1, (149), 1984, pp.40-44.

HUTCHINS, TOM. "Three New Zealand photographers: Fiona Clark, Laurence Aberhart, Peter Peryer." *Art New Zealand*, 14, 1979, pp.17-19.

IRELAND, PETER. "The favourable furrow: notes from the 'M.T. Woollaston Works 1933-1973' exhibition." *Islands*, 3, 2, 1974, pp.181-192.

IRELAND, PETER. "Peter Peryer: the significance of repetition." *Art New Zealand*, 31, 1984, pp.34-35.

ISLANDS. "Nineteen painters: their favourite works." *Islands*, 3, 4, 1974, pp.373-400.

JOHNSON, JOHN. "Notes from a journal", 1847, in Taylor 1959, pp.116-185.

JOHNSTON, ALEXA M. "John Holmwood: thirty years of his painting." *Art New Zealand*, 31, 1984, pp.42-45 = Johnston 1984a.

JOHNSTON, ALEXA M. *Anxious Images* (exhibition catalogue), Auckland City Art Gallery, 1984 = Johnston 1984b.

JOHNSTON, ARTHUR. "Pumpkin Cottage: the artists' rendezvous." *Art in New Zealand*, 14, 4, (56), June 1942, pp.193-194.

JONES, R. "Gustavus Ferdinand von Tempsky (1828-68)" in McLintock 1966, vol.3, pp.378-379.

JOPPIEN, RÜDIGER. "Three drawings by William Hodges." *La Trobe Library Journal*, 5, 18, 1976, pp.25-33.

JOPPIEN, RÜDIGER, & SMITH, BERNARD. *The Art of Captain Cook's Voyages. Volume two: The Voyage of the Resolution and Adventure 1772-1775.* Yale University Press, New Haven, 1985.

KAY, ROBIN & EDEN, TONY. *Portrait of a Century: the History of the N.Z. Academy of Fine Arts.* Millwood Press, Wellington, 1983.

KEITH, HAMISH. *John Kinder* (exhibition catalogue), Auckland City Art Gallery, 1958.

KEITH, HAMISH. *Early Watercolours of New Zealand* (exhibition catalogue), Auckland City Art Gallery, 1963.

KEITH, HAMISH. *New Zealand Art: Painting 1827-1890.* A.H. & A.W. Reed, Wellington, 1968.

KEITH, HAMISH. "Christopher Perkins in New Zealand." *Art New Zealand*, 1, 1976, pp.16-17.

KEITH, HAMISH. "Patrick Hanly: a conversation." *Art New Zealand*, 14, 1979, pp.44-51.

KEITH HAMISH. *Images of Early New Zealand.* David Bateman, Auckland, 1983.

KEITH, SHERIDAN. "A conversation with Don Binney." *Art New Zealand*, 28, 1983, pp.18-20.

KERR, JOAN (ed.) *Dictionary of Australian Artists. Working Paper I: Painters, Photographers and Engravers 1770-1870*, Power Institute of Fine Arts, University of Sydney, 1984.

KILLICK, E.A.S. "Landscape art in New Zealand", in Holmes 1917, pp.85-90.

KING, JULIE. "In pursuit of sublime landscape: round the Sounds in the Hawea." *Art New Zealand*, 47, 1988, pp.99-103.

KING, JULIE. "W.M. Hodgkins and his American 'cousins'." *Bulletin of New Zealand Art History*, 10, 1989, pp.5-9.

KING, RICHARD. *The Kelliher: 67 Award Winning Paintings.* Orakau House, Auckland, 1979.

KIRKER, ANNE & YOUNG, ERIC. *The Watercolours of Alfred Sharpe* (exhibition catalogue), Auckland City Art Gallery, 1973.

KIRKER, ANNE. "T.A. McCormack: a new talent to emerge in the nineteen-thirties." *Art New Zealand*, 27, 1983, pp.34-39.

KIRKER, ANNE. *New Zealand Woman Artists.* Reed Methuen, Auckland, 1986.

KNIGHT, HARDWICKE. *Photography in New Zealand: a Social and Technical History.* John McIndoe, Dunedin, 1971.

KNIGHT, HARDWICKE. *New Zealand Photographers: a Selection.* Allied Press, Dunedin, 1981.

LANDER, MAUREEN. "Kohukohu or Horeke? An investigation of Charles Heaphy's 'View of the Kahukahu, Hokianga River' 1839." *ANTIC*, 5, 1989, pp.106-119; edited version in *Turnbull Library Record*, 22, 1, 1989, pp.33-40.

LAWTON, EILY M. "Christopher Perkins: the New Zealand years." Unpublished M.A. thesis, University of Auckland, 1975.

LEE, G. LINCOLN. "The art of John Gully." *Art in New Zealand*, 7, 3, (27), March 1935, pp.113-116 = Lee 1935a.

LEE, G. LINCOLN. *John Gully: a New Zealand Artist.* Bryant Duplicating Bureau, Auckland, 1935 = Lee 1935b.

LEE-JOHNSON, ERIC. "Eric Lee-Johnson." *Year Book of the Arts* in New Zealand, 3, 1947, pp.72-75.

LEE-JOHNSON, ERIC. "Northland photographs." *Landfall*, 6, 1, (21), 1952, pp.31-32.

LEE-JOHNSON, ERIC. "A gentle occupation." *Landfall*, 7, 4, (28), 1953, pp.269-271.

LEE-JOHNSON, ERIC. "The wooden graves of Northland." *Landfall*, 12, 1, (48), 1958, pp.57-58.

LEE-JOHNSON, ERIC. *As I see it: Drawings from North New Zealand*. Collins, Auckland, 1969.

LEECH, PETER. "Milan Mrkusich: the architecture of the painted surface." *Art New Zealand*, 19, 1981, pp.34-39.

LEECH, PETER & WILSON, T.L. RODNEY. *Milan Mrkusich, a Decade Further On, 1974-1983* (exhibition catalogue), Auckland City Art Gallery, 1985.

LLOYD, TREVOR. "Icons of the bush: etchings of Trevor Lloyd", typescript of unpublished monograph, c.1985, Auckland City Art Gallery archive = Lloyd MS.

LOCKE, ELSIE & PAUL, JANET. *Mrs Hobson's Album*. Auckland University Press, Auckland, 1989.

McCAHON, COLIN. *J.C. Richmond* (exhibition catalogue), Auckland City Art Gallery, 1957.

McCAHON, COLIN. *James Nairn and Edward Friström* (exhibition catalogue), Auckland City Art Gallery, 1964.

McCAHON, COLIN. "Beginnings." *Landfall*, 20, 4, (80), 1966, pp.360-364.

McCAHON, COLIN & O'REILLY, R.N. *Colin McCahon: a Survey Exhibition* (exhibition catalogue), Auckland City Art Gallery, 1972.

McCAHON, COLIN. "Necessary protection." *Art New Zealand*, 7, 1977, p.45.

McCORMACK, T.A. "T.A. McCormack." *Year Book of the Arts in New Zealand*, 3, 1947, pp.60-63.

McCORMICK, E.H. *Letters and Art in New Zealand*. Department of Internal Affairs, Wellington, 1940.

McCORMICK, E.H. "From Charles Heaphy to Frances Hodgkins: a biographical view of New Zealand painting." *Year Book of the Arts in New Zealand*, 5, 1949, pp.145-152.

McCORMICK, E.H. "The Louise Henderson exhibition: a note in retrospect." *Landfall*, 8, 1, (29), 1954, pp.54-55.

McCORMICK, E.H. *Eric Lee-Johnson*. Paul's Book Arcade, Hamilton, 1956.

McCORMICK, E.H. "Frances Irwin Hunt, 1890-1981: a personal note." *Art New Zealand*, 22, 1981-82, pp.39-41.

McCRACKEN, JOAN & SULLIVAN, JOHN. "Women photographers in the Turnbull Library." *Turnbull Library Record*, 19, i, 1986, pp.52-60.

McCULLOCH, ALAN. *Encyclopedia of Australian Art*. Hutchinson, Melbourne, 1968.

MACKANESS, G. (ed.). *The Australian Journal of William Strutt A.R.A. 1850-1862*. (2 vols.), Halstead Press, Sydney, 1958.

MACKLE, ANTHONY. *Aspects of New Zealand Art 1890-1940* (exhibition catalogue), National Art Gallery, Wellington, 1984.

MACLENNAN, S.B. *Early New Zealand Watercolours and Drawings from the Chevalier, J.C. Richmond and Swainson Collections* (exhibition catalogue, National Art Gallery), Government Printer, Wellington, 1961.

MACLENNAN, S.B. "Art in New Zealand: section II, surveys, trends, and influences, 1938 to present", in McLintock 1966, vol. 1, pp.86-91.

MACLENNAN, S.B. "Alfred Wilson Walsh (1859-1916)", in McLintock 1966, vol.3, p.542.

McLINTOCK, A.H. *National Centennial Exhibition of New Zealand Art* (exhibition catalogue), Department of Internal Affairs, Wellington, 1940.

McLINTOCK, A.H. *An Encyclopedia of New Zealand*. (3 vols.), Government Printer, Wellington, 1966.

McLINTOCK, A.H. "Art in New Zealand: section I, beginnings: 1642-1939", in McLintock 1966, vol. 1, pp.82-86.

MAIN, WILLIAM. *Wellington through a Victorian Lens*. Millwood Press, Wellington, 1972.

MAIN, WILLIAM. *Auckland through a Victorian Lens*. Millwood Press, Wellington, 1977.

MAIN, WILLIAM. "William Thomas Locke Travers (1819-1903) and his photographs of Wellington's northern suburbs." *Onslow Historian*, 15, 3, 1985, pp.3-5.

MARTIN, JOSIAH. "The Waitakerei Falls." *New Zealand Herald*, 7 March 1885, supplement, p.1.

MERRETT, J.J. "Narrative of proceedings leading to the capture of Pomare." *New Zealand Journal*, 5, 152, October 1845, p.271.

MILLAR, D.P. *Doris Lusk Retrospective* (exhibition catalogue), Dowse Art Gallery, Lower Hutt, 1973.

MILLAR, D.P. *W.A. Sutton Retrospective* (exhibition catalogue), Dowse Art Gallery, Lower Hutt, 1973.

MILLAR, D.P. *Patrick Hanly Retrospective* (exhibition catalogue), Dowse Art Gallery, Lower Hutt, 1974.

MILLAR, D.P. *Brian Brake: 40 Photographs* (exhibition catalogue), Dowse Art Gallery, Lower Hutt, 1976.

MILLIGAN, R.R.D. "Nugent Welch: the artist and the man." *Art in New Zealand*, 16, 2, (62), December 1943, p.4-5.

MITCHELL, ALISON. *Olivia Spencer Bower Retrospective* (exhibition catalogue), Robert McDougall Art Gallery, Christchurch, 1977.

MORRELL, W.P. "Sir William Fox (1812-93)", in McLintock 1966, vol.1, pp.744-746.

MORRISON, ROBIN. *The South Island of New Zealand: From the Road*. Alister Taylor, Martinborough, 1981.

MUIR, BRIAN. "Landscape painting in New Zealand." *Education*, 22, 1-10, 1973.

MUIR, BRIAN. "Sydney Lough Thompson (1877-1973)." *Robert McDougall Art Gallery Survey*, 14, 1976.

MURRAY-OLIVER, ANTHONY. *The Rex Nan Kivell Collection of Early New Zealand Pictures* (exhibition catalogue, Alexander Turnbull Library), Department of Internal Affairs, Wellington, 1953.

MURRAY-OLIVER, ANTHONY. *Oil Paintings by William Hodges, R.A.* (exhibition catalogue), Government Printer, Wellington, 1959.

MURRAY-OLIVER, ANTHONY. *Augustus Earle in New Zealand*. Whitcombe & Tombs, Christchurch, 1968.

MURRAY-OLIVER, ANTHONY. *Captain Cook's Artists in the Pacific*. Avon Fine Prints, Christchurch, 1969.

MURRAY-OLIVER, ANTHONY. "Augustus Earle paints New Zealand." *New Zealand's Heritage*, 11, 1971, pp.298-303.

MURRAY-OLIVER, ANTHONY. "Charles Heaphy: soldier, artist and surveyor." *New Zealand's Heritage*, 32, 1972, pp.891-896.

MURRAY-OLIVER, ANTHONY. "Artists of the 1850s and 1860s." *New Zealand's Heritage*, 34, 1972, pp.943-947.

MURRAY-OLIVER, ANTHONY. "Art in New Zealand 1870-1900." *New Zealand's Heritage*, 43, 1972, pp.1194-1199.

MURRAY-OLIVER, ANTHONY. "Art in a new century." *New Zealand's Heritage*, 68, 1972, pp.1882-1887.

MURRAY-OLIVER, ANTHONY. "Views of the Wanganui Campaign 1865, by Lieutenant-General E.A. Williams, C.B." Text-sheet accompanying *The E.A. Williams Prints*, Alexander Turnbull Library, Wellington, 1980.

MURRAY-OLIVER, ANTHONY. "Views in Hawke's Bay 1855-61 by Alfred John Cooper (d.1869)." Text-sheet accompanying *The Cooper Prints*, Alexander Turnbull Library, Wellington 1980.

MURRAY-OLIVER, ANTHONY. *A Folio of Watercolours by Charles Heaphy, V.C. (1821-1881)*. Avon Fine Prints, Christchurch, 1981.

NAIRN, J.M. "The progress of art in New Zealand." *New Zealand Mail*, 6 October 1892, p.11.

NAIRN, J.M. "Some notes on landscape painting." *New Zealand Mail*, 23 April 1896, p.13.

NICOLL, A.F. "Van der Velden's influence on New Zealand art: interview with Archibald F. Nicoll." *Art in New Zealand*, 1, 1, (1), September 1928, pp.30-32.

NICOLL, A.F. "Archibald F. Nicoll." *Year Book of the Arts in New Zealand*, 3, 1947, pp.41-43.

OLIVER, W.H. "Richmonds and Atkinsons." *Landfall*, 17, 2, (66), 1963, pp.177-187.

O'KEEFFE, A.H. "Art in retrospect: earlier Dunedin days, paint and personality." *Art in New Zealand*, 12, 33, (47), March 1940, pp.156-162.

O'REILLY, R.N. "M.T. Woollaston: art and development." *Landfall*, 2, 3, (7), 1948, pp.208-213.

PAUL, JANET. "Painting 1920-1950." *New Zealand's Heritage*, 84, 1973, pp.2330-2336.

PAUL, JANET. "Twelve watercolours of glaciers in the Province of Canterbury." *Art New Zealand*, 8, 1977-78, pp.56-59.

PAUL, JANET. *The Paintings of Margot Philips* (exhibition catalogue), Waikato Art Museum, Hamilton, 1983.

PAUL, JANET. "What makes Rita Angus different?." *Art New Zealand*, 26, 1983, pp.28-31.

PAUL, JANET et al. *Rita Angus* (exhibition catalogue), National Art Gallery, Wellington, 1983.

PAUL, JANET. "Margot Philips." *Art New Zealand*, 46, 1988, pp.84-87.

PERKINS, CHRISTOPHER. "Arrival." *Art in New Zealand*, 2, 5, (5), September 1929, pp.15-16.

PERKINS, CHRISTOPHER. "The story of Christopher Perkins." *Art in Australia*, 48, February 1933, pp.29-37.

PERKINS, CHRISTOPHER. "The temptations of England." *Art in New Zealand*, 7, 1, (25), September 1934.

PERYER, PETER. "Peter Peryer: the photograph as a portrait of the self." *Art New Zealand*, 8, 1977-78, pp.25, 65-67.

PETERSEN, A.K.C. "R.N. Field: the Dunedin years 1925-1945." Unpublished M.A. thesis, University of Canterbury, 1987.

PETERSEN, A.K.C. *R.N. Field: the Dunedin Years 1925-1945* (exhibition catalogue), Manawatu Art Gallery, Palmerston North, 1989.

PHILLIPS, JOCK (ed.). *Te Whenua, Te Iwi: the Land and the People*. Allen & Unwin/Port Nicholson Press, Wellington, 1987.

PLATTS, UNA. *Nineteenth Century New Zealand Artists: a Guide and Handbook*. Avon Fine Prints, Christchurch, 1980.

PLATTS, UNA. "James Crowe Richmond 1822-1898: artist, politician, civil engineer." *Art New Zealand*, 29, 1983, pp.46-51.

PORSOLT, I.V. "Retrospectives: M.T. Woollaston and Colin McCahon." *Landfall*, 17, 3, (67), 1963, pp.272-275.

POUND, FRANCIS. "Spectator figures in some New Zealand paintings and prints." *Art New Zealand*, 23, 1982, pp.40-45.

POUND, FRANCIS. *Frames on the Land: Early Landscape Painting in New Zealand*. Collins, Auckland, 1983 = Pound 1983a.

POUND, FRANCIS. "A battle of the critics: the concept of the avant-garde comes to New Zealand." *Art New Zealand*, 28, 1983, pp.24-27 = Pound 1983b.

POUND, FRANCIS. "Harsh clarities: meteorological and geographical determinism in New Zealand art commentary refuted." *Parallax*, 3, 1983, pp.263-269.

POUND, FRANCIS. *Forty Modern New Zealand Paintings*. Penguin, Auckland, 1985.

POUND, FRANCIS. "The land, the light, and nationalist myth in New Zealand art", in Phillips 1987, pp.48-60.

REED, A.W. (ed.). *Maori Scenes and Portraits: Illustrated and Described by George French Angas*. A.H. & A.W. Reed, Wellington, 1979.

REED, A.W. (ed.). *Early Paintings of the Maori: Illustrated and Described by George French Angas*. A.H. & A.W. Reed, Wellington, 1979.

RENNIE, SARAH. "W.A. Sutton and the Canterbury landscape." Unpublished M.A. thesis, University of Canterbury, 1985.

RENNIE, SARAH. "W.A. Sutton: portraits of the Canterbury landscape." *Art New Zealand*, 40, 1986, pp.58-61, 82.

ROBERTSON, P.W. "The art of Christopher Perkins." *Art in New Zealand*, 4, 13, (13), September 1931, pp.8-23.

ROSS, JAMES. "A singular vision: the paintings of Tony Fomison." *Art New Zealand*, 2, 1976, pp.21-23.

ROSS, JAMES & SIMMONS, LAURENCE (eds.). *Gordon Walters: Order and Intuition*. Walters Publication, Auckland, 1989.

SCHOLEFIELD, G.H. (ed.). *A Dictionary of New Zealand Biography*. (2 vols.), Department of Internal Affairs, Wellington, 1940.

SCHOLEFIELD, G.H. *The Richmond-Atkinson Papers*. (2 vols.), Government Printer, Wellington, 1960.

SHARPE, ALFRED. "Hints for landscape students in water-colour." *New Zealand Herald*, 21 August 1880, p.6; 11 September 1880, p.6; 18 September 1880, p.6; 9 October 1880, p.6; 6 November 1880, p.6; 4 December 1880, p.6; 26 March 1881, p.6; 16 April 1881, p.6; *Auckland Weekly News*, 11 November 1882, supplement, p.3; typescript in Blackley 1978, pp.1-51.

SHELLEY, JAMES. "Archibald F. Nicoll: painter." *Art in New Zealand*, 5, 17, (17), September 1932, pp.37-40.

SHELLEY, JAMES. "Sydney L. Thompson: painter." *Art in New Zealand*, 8, 3, (31), March 1936, pp.129-139.

SHEPARD, PAUL. *English Reaction to the New Zealand Landscape before 1850*. Pacific Viewpoint Monograph No. 4, Victoria University, Wellington, 1969.

SHURROCK, FRANCIS A. "William H. Allen." *Art in New Zealand*, 13, 1, (49), September 1940, pp.5-14.

SIDDELL, PETER. "Peter Siddell talks to Art New Zealand." *Art New Zealand*, 43, 1987, pp.42-45, 87.

SMART JONATHAN. "Pat Hanly." *Landfall*, 35, 4, (140), 1981, pp.421-429.

SMITH, BERNARD. *European Vision and the South Pacific 1768-1850: a Study in the History of Art and Ideas*. Oxford University Press, Oxford, 1960.

SOTHERAN, CHERYLL. "The later paintings of William Fox." *Art New Zealand*, 11, 1978, pp.42-49.

STANDISH, M.W. "Charles Heaphy (1820-81)", in McLintock 1966, vol.2., pp.9-10.

STEAD, C.K. "The development of Louise Henderson's vision: a personal note." *Artis*, 1, 3, 1971, pp.25-26.

STONES, ANTHONY. "A signwriting prophet: a note on the painter, Colin McCahon." *Landfall*, 25, 2, (98), 1971, pp.156-159.

STUEBE, ISABEL COMBS. *The Life and Works of William Hodges*. Garland: Outstanding Dissertations in the Fine Arts, New York, 1979.

SUMMERS, JOHN. "The Woollaston country: a partisan review." *Ascent*, 1, 1, 1967, pp.4-10.

SUMMERS, JOHN. "Doris Lusk: an appreciation." *Art New Zealand*, 40, 1986, pp.54-57.

SYDNEY, GRAHAME. "The frame is the dictator." *Art New Zealand*, 7, 1977, pp.44-45.

SYDNEY, GRAHAME. "The given image." *Landfall*, 32, 3, (127), 1978, p.240.

TAYLOR, ALISTER & BROWN, GORDON H. *Robin White, New Zealand Painter*. Alister Taylor, Martinborough, 1981.

TAYLOR, NANCY M. (ed.). *Early Travellers in New Zealand*. Oxford University Press, Oxford, 1959.

TAYLOR, WALTER. "Robert Johnson: an appreciation." *Art in Australia*, 54, February 1934, pp.18-21.

TELFORD, HELEN & MAIN, WILLIAM. *George Chance Photographs* (exhibition catalogue), Dunedin Public Art Gallery, 1985.

TEMPSKY, G.F. von. "Memoranda of the New Zealand campaign in 1863 and 1864." Manuscript, Alexander Turnbull Library = von Tempsky MS.

THOMPSON, SYDNEY L. "Art in the twentieth century, I & II." *Art in New Zealand*, 12, 1, (45), September 1939, pp.42-46, and 12, 2, (46), December 1939, pp.105-109.

THOMPSON, SYDNEY L. "An all-embracing view." *Art in New Zealand*, 15, 4, (60), June 1943, pp.8-9, 18.

TOMORY, P.A. *Captain James Cook: his Artists and Draughtsmen* (exhibition catalogue), Auckland City Art Gallery, 1964.

TOMORY, P.A. *New Zealand Art: Painting 1890-1950.* A.H. & A.W. Reed, Wellington 1968.

TOMORY, P.A. "Imaginary reefs and floating islands: the romantic image in New Zealand painting." *Ascent*, 2, 1968, pp.5-19.

TRAVERS, W.T.L. "On the changes effected in the natural features of a new country by the introduction of civilized races." *Transactions and Proceedings of the New Zealand Institute, 1869*, 2, Wellington, 1870, pp.299-330.

TRAVERS, W.T.L. "Notes on the practice of out-door photography (read before the Wellington Philosophical Society, 28th October, 1871)." *Transactions and Proceedings of the New Zealand Institute, 1871*, 4, Wellington, 1872, pp.160-164. Reprinted in Main 1985.

TREGENZA, JOHN. *George French Angas: Artist, Traveller and Naturalist 1822-1886.* Art Gallery of South Australia, Adelaide, 1980.

TRIPE, M.E.R. "James McLachlan Nairn: some personal reminiscences." *Art in New Zealand*, 1, 2, (2), December 1928, pp.105-106.

TURNER, JOHN B. *Nineteenth Century New Zealand Photographs* (exhibition catalogue), Govett-Brewster Art Gallery, New Plymouth, 1970.

WADMAN, HOWARD. "Cedric Savage." *Year Book of the Arts in New Zealand*, 4, 1948, pp.66-69.

WAKEFIELD, EDWARD JERNINGHAM. *Adventure in New Zealand, from 1839 to 1844.* (2 vols.), John Murray, London, 1845.

WALKER, TIM. *Margot Philips: her own world* (exhibition catalogue), Waikato Museum of Art and History, Hamilton, 1987.

WATERHOUSE, B.J. "Robert Johnson." *Art in Australia*, 54, February 1934, pp.18-21.

WATKINS, KENNETT. Speech quoted in "Formation of an Art Students' Association." *New Zealand Herald*, 13 December 1883, p.6 = Watkins 1883a.

WATKINS, KENNETT. Speech quoted in "Meeting of the New Zealand Art Students' Association." *New Zealand Herald*, 24 December 1883, p.6 = Watkins 1883b.

WAUCHOP, W.S. "Alfred Wilson Walsh." *Art in New Zealand*, 13, 2, (50), December 1940, pp.59-60.

WAUCHOP, W.S. "Roland Hipkins and Jenny Campbell." *Art in New Zealand*, 9, 4, (36), June 1937, pp.177-187.

WHITE, ROBIN. "Art and conservation are synonymous." *Art New Zealand*, 7, 1977, pp.40-41.

WILLIAMS, MURIEL. *Charles Blomfield: his Life and Times.* Hodder and Stoughton, Auckland, 1979.

WILSON, ELIZABETH. "R.N. Field interview." *Bulletin of New Zealand Art History*, 8, 1980, pp.12-24.

WILSON, ELIZABETH. "Edward Friström: interpretations of the landscape." *Art New Zealand*, 19, 1981, pp.42-45 = Wilson 1981a.

WILSON, ELIZABETH. "Edward Friström." Unpublished M.A. thesis, University of Auckland, 1981 = Wilson 1981b.

WILSON, T.L. RODNEY. "Petrus van der Velden: the Marken and Otira series." *Art New Zealand*, 1, 1976, pp.21-23.

WILSON, T.L. RODNEY. "Notes toward a van der Velden mythology." *Art New Zealand*, 4, 1977, pp.29-31.

WILSON, T.L. RODNEY. *Petrus van der Velden (1837-1913): a Catalogue Raisonné.* (2 vols.), Chancery Chambers, Sydney, 1979.

WOODWARD, JOAN. *A Canterbury Album.* Te Waihora Press, Lincoln, 1987.

WOOLLASTON, M.T. "Mr Tosswill Woollaston: a little known N.Z. artist interviews our reporter." *Art in New Zealand*, 10, 1, (37), September 1937, pp.7-13.

WOOLLASTON, M.T. "The value of locality in art." *Landfall*, 15, 1, (57), 1961, pp.73-76.

WOOLLASTON, M.T. *The Far-away Hills: a Meditation on New Zealand Landscape.* Auckland Gallery Associates, Auckland City Art Gallery, 1962.

WOOLLASTON, M.T. *Sage Tea: an Autobiography.* Collins, Auckland, 1980.

WOOLLASTON, M.T. "A narrow peep at New Zealand art." *Turnbull Library Record*, 15, 1 May 1982, pp.15-29.

YOUNG, MARK. *New Zealand Art: Painting 1950-1967.* A.H. & A.W. Reed, Wellington, 1968.

YOUNG, ROSE & MURRAY-OLIVER, ANTHONY. *Gustavus Ferdinand von Tempsky: the Man and the Artist* (exhibition catalogue), Waikato Art Museum, 1978.

YOUNG, ROSE; CURNOW, HEATHER & KING, MICHAEL. *G.F. von Tempsky: Artist & Adventurer.* Alister Taylor, Martinborough, 1981.